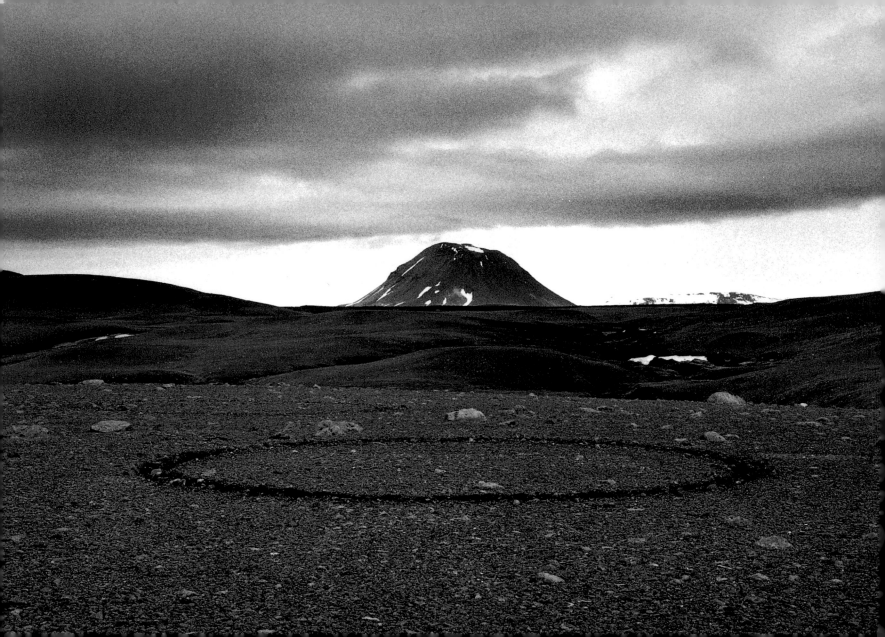

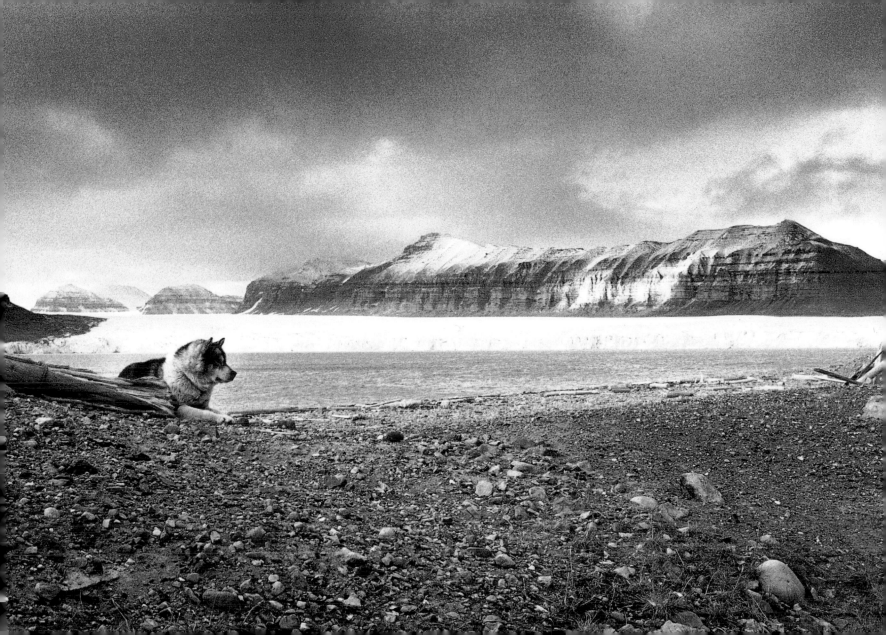

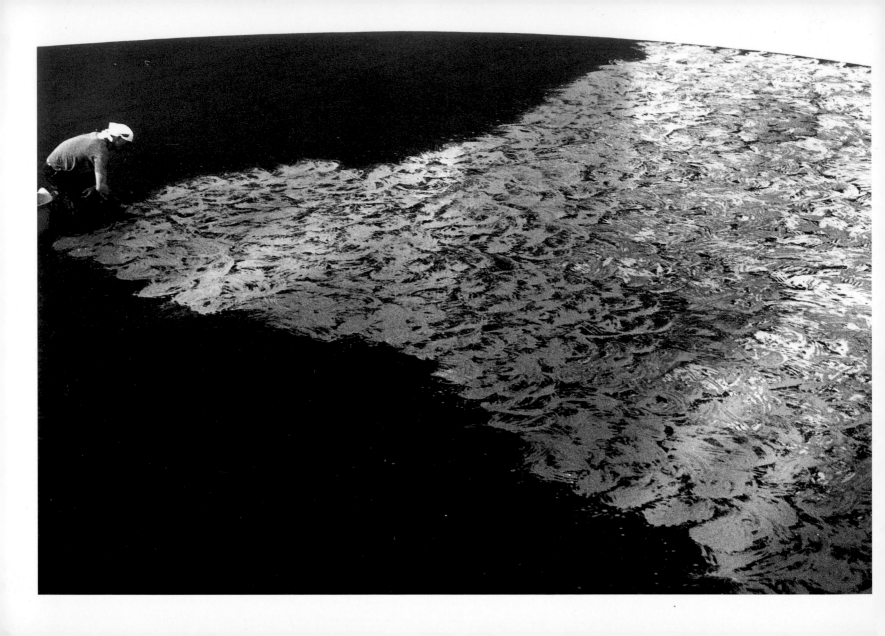

RICHARD LONG
MIRAGE

Φ

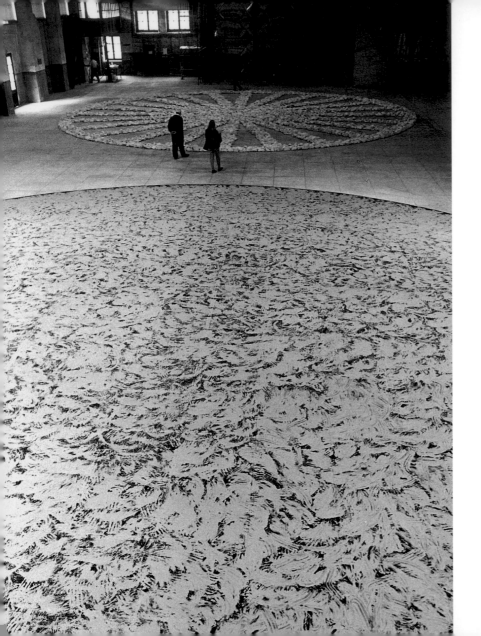

SICILIAN MUD HAND CIRCLE (detail, left)
and CIRCLE OF LIFE (right)
SPAZIO ZERO PALERMO 1997

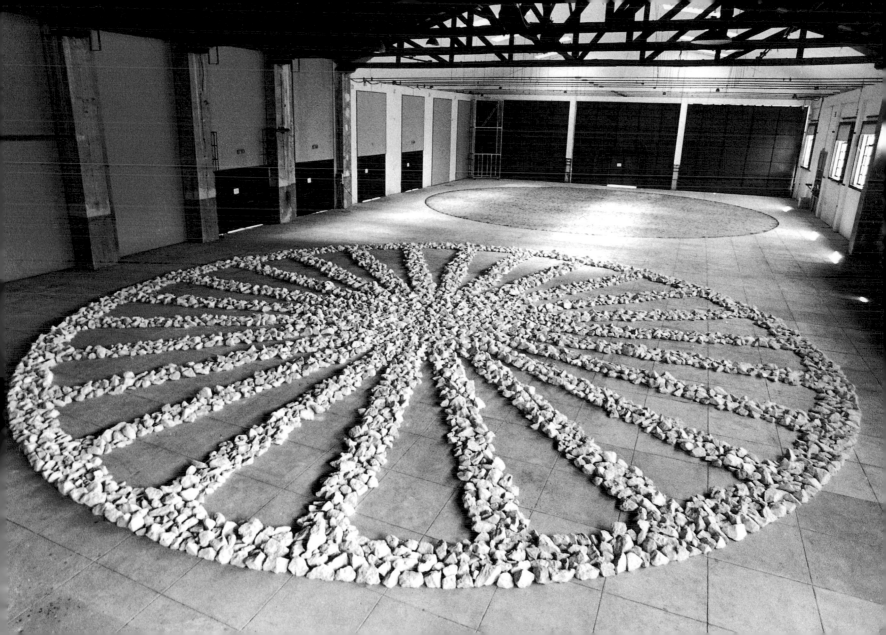

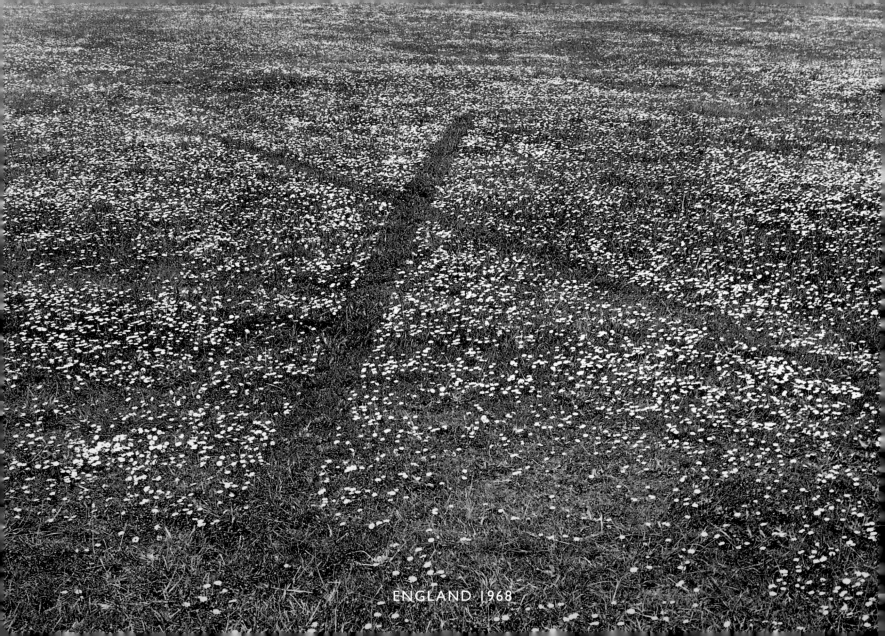
ENGLAND 1968

INTRODUCTION

Alison Sleeman

Richard Long's work is remarkably consistent and simple. Elementary geometric forms, natural materials and a straightforward use of words link works across three decades. Central to his practice is walking. Walking in the landscape and making art out of the landscape are aspects of a rich and diverse landscape tradition. Revealing a new perspective on that tradition, Richard Long is often credited as the artist who demonstrated that a walk could be a sculpture.

As Hamish Fulton remarked, 'after leaving St. Martin's School of Art he did not look for a job. He made sculpture.' But even before he left art school Richard Long had made sculpture in an international context – as part of an exhibition in Frankfurt in 1967. The following year he had a one-person exhibition at Konrad Fischer's gallery in Düsseldorf and sold his first work, financing the first of many working trips abroad – to East Africa in 1969, where he made a sculpture on the summit of Mount Kilimanjaro and also a walk along the Equator.

Within a few years of leaving art school he had participated in a number of ground-breaking international exhibitions such as *Op Losse Schroeven* (Stedelijk Museum, Amsterdam, 1969), *When Attitudes Become Form* (Kunsthalle, Berne, 1969), *Information* (The Museum of Modern Art, New York, 1970) and the *Guggenheim International* (Solomon R. Guggenheim Museum, New York, 1971). This located Long's work in a dynamic international milieu where the conditions, definitions and practices of art making were being questioned and redefined.

Along with other important artists from that formative period, Richard Long's work shares a concern with the importance of ideas and with how the work comes into being. This involves both how the work is made and how it is revealed in a wider cultural environment. Long's work is sensitive to its location in the world and in the world of art.

As well as its relationship to the world and to the spaces of galleries and museums, there are a number of other important relationships in the work. For the artist the work is a personal odyssey embracing a vital meditation on the relationship between himself and the world. The work's relation to a longer landscape tradition, as a radical reworking of that tradition, secures its importance in broader historical terms. The work can be seen in the context of art history, as part of a broader cultural history, and as personal history: as autobiography.

At its most basic, Richard Long's work in its various forms in the landscape, in the gallery or in books, is an attempt to communicate the experience of being in the landscape or walking in the landscape, as a work of art. This brings us to one final and crucial relationship: that between the viewer and the work.

For the viewer, or reader of this book, a single work offers many possible interpretations. A sequence of works multiplies that potential. In this book places as distant as Italy, Tokyo, Bristol, Spitzbergen and Patagonia can be brought close together. The works are linked together in the book's pages and by the artist, who commented in 1982: 'My work has become a simple metaphor of life. A figure walking down his road.' It is a walk across continents that constantly returns metaphoriclly as well as actually to the place – Bristol – where Richard Long grew up and where he still lives and works.

The story told in this selection of works embraces the deeply personal and the deliberately public: from memories of personal experiences and friendship, to works experienced in galleries and museums worldwide.

As a fixed point in time and place, the experience of the book, like a stopping place on a walk, offers a moment to reflect on the journey thus far, and perhaps peruse the map or surrounding landscape for an indication of where to go next. In this sense such a book can never be a retrospective, never only a looking back, always rather a work – or a walk – in progress

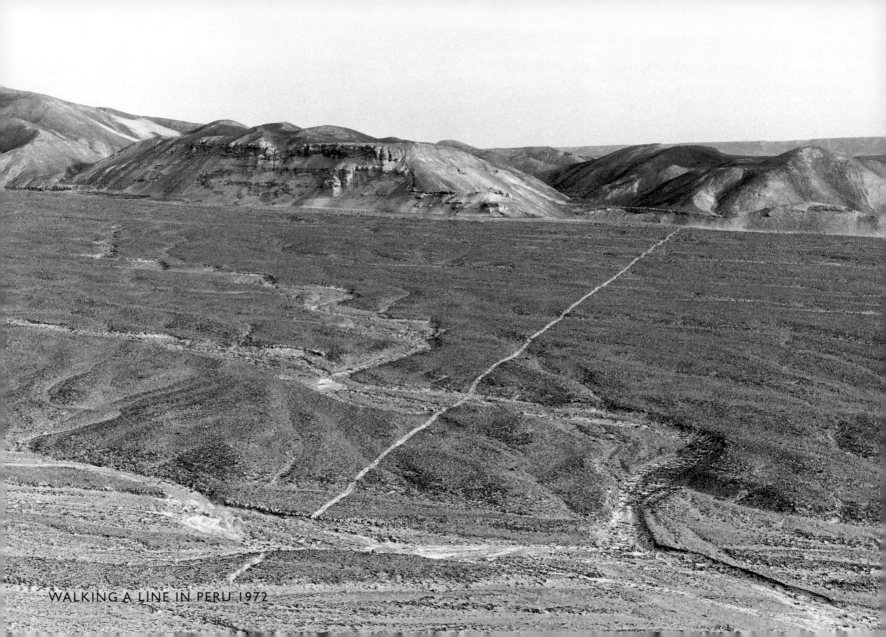

WALKING A LINE IN PERU 1972

FROM LINE TO LINE

A BOOT-HEEL LINE IN DUST IN RIO MAYO

A BOOT-HEEL LINE IN DUST IN PERITO MORENO

A BOOT-HEEL LINE IN MUD IN CALETA OLIVIA

A BOOT-HEEL LINE IN MUD IN FITZ ROY

A BOOT-HEEL LINE IN MUD PUERTO SAN JULIÁN

A BOOT-HEEL LINE IN SNOW IN RIO GALLEGOS

A BOOT-HEEL LINE ON ICE IN ESPERANZA

A BOOT-HEEL LINE IN DUST IN EL CALAFATE

A BOOT-HEEL LINE IN SNOW IN TOLHUIN

A BOOT-HEEL LINE IN SNOW IN USHUAIA

PATAGONIA AND TIERRA DEL FUEGO

ARGENTINA 1997

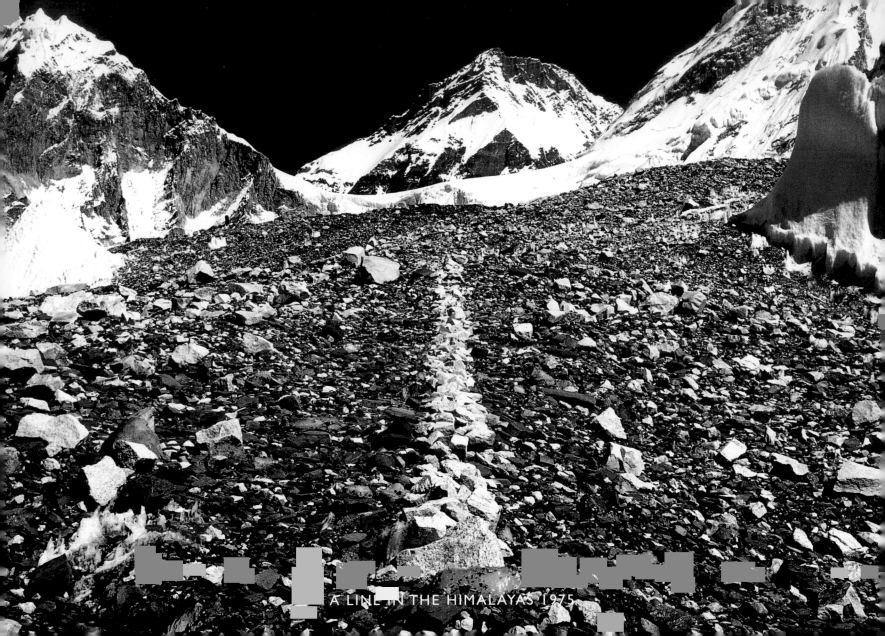

A LINE IN THE HIMALAYAS 1975

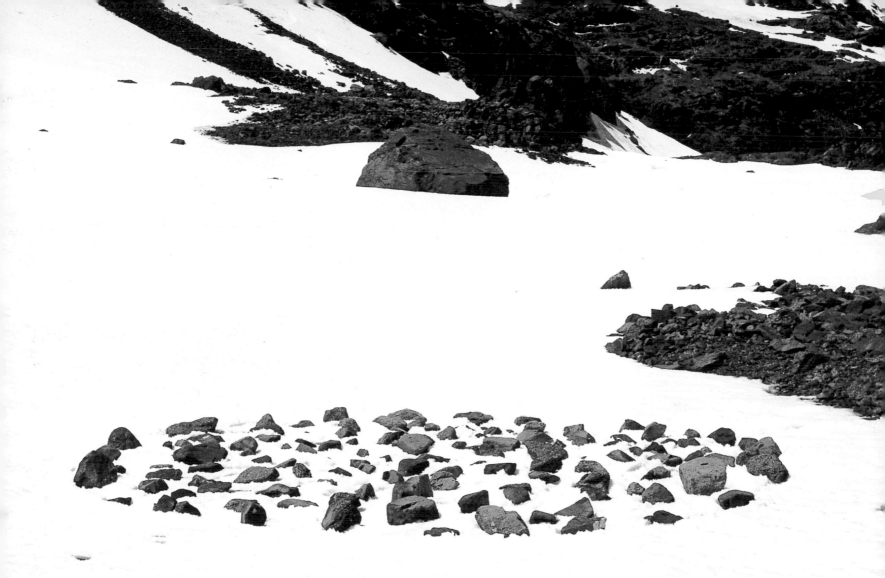

THROWING STONES INTO A CIRCLE A SIX DAY WALK IN THE ATLAS MOUNTAINS MOROCCO 1979

INTERVIEW

between Geórgia Lobacheff and **Richard Long**, 1994

GL Do you consider yourself to be an artist or a sculptor? Could you classify your work as Land Art?

RL I call myself an artist. Nature is the source of my work. The medium of my work is walking (the element of time) and natural materials (sculpture). For me, the label 'Land Art' represents North American monumental earthworks, and my work has nothing to do with that. I could say it perhaps has more in common with Italian Arte Povera (simple, modest means and procedures) or Conceptual Art (the importance of ideas).

GL How do your works originate? Do you first have the idea then choose the place where you walk in order to transform the idea into sculpture? Or does the work evolve from walking?

RL I often use both ways of working.

GL What determines the places you travel to?

RL I have made walks for many and various and precise reasons. I could choose a place or route to realize a particular idea for a walk, or because I know it from experience, or because I knew it from a map, or even because I didn't know it (almost for no reason at all).

GL Why do you use sticks and stones in your work?

RL All my work is about my choices, my preferences. I like stones, so I use them, in the same way I make art by walking because I like walking. Stones are practical, they are common, they exist almost all over the world, they are easy to pick up and carry, they are all unique, universal and natural. But I also use other materials, like mud and water. My preference is always for simple, elemental and natural materials.

GL Why do most of your works involve either a circle or a path?

RL They are timeless, universal, understandable and easy to make. I am interested in the emotional power of simple images.

GL Has the human body been both a system of measurement and a map for you?

RL My work is really a self-portrait, in all ways. It is about my own physical engagement with the world, whether walking across it or moving its stones around. To walk across a country is both a measure of the country itself (its size, shape and terrain) and also of myself (how long it takes me and not somebody else). In other works, like my hand circles in mud, or waterlines, my work is more obviously an image of my gestures.

GL Can you tell me something about your art education?

RL I spent most of my childhood drawing and painting, so art was already my 'language' when I went to art school, although I only started to make sculpture when I was about nineteen. It seemed at that time, to me, the best way to be inventive and experimental. I studied art in two English art schools, in Bristol and London, where there is a good tradition of imaginative and independent fine art education.

GL When did you first start making works through walking?

RL In 1967. At first it was small scale, walking a line in a field, but as it was practical, for example, to make a straight ten mile walk in an open, wilderness area, so the walks grew naturally, over the years, into the landscapes of the world.

GL Are your works intended to be seen from a specific view-point?

RL Sometimes. I made a work in 1967 consisting of three places: the places of two parts of the sculpture, widely spaced, plus the place of the viewer, the idea being that all three places had to be in line for the work to be 'complete'.

GL You take pictures of your work. Do you consider yourself a photographer?

RL I am an artist who sometimes chooses to use photographs, although I am not a photographer. The photo works are one part of the various forms I use to realize my work, and they are equal and complementary to the text works, the map works, sculptures, water lines, mud works etc. A photograph is one way to bring the image or idea of a remote or temporary sculpture to the public, although a photo work necessarily becomes art in a different way than the original sculpture. Art can be known about as well as seen. I also like the fact that the place of some sculptures can and should remain anonymous, or could be so remote as to be unvisited.

GL How did you become interested in using the wind as a raw material to make sculpture?

RL Because it's an elemental part of nature, it's often part of a walk, it's part of the energy in the world.

GL Can you say something about the relationship between the outdoor and indoor works?

RL The outdoor works and indoor works are complementary, although I would have to say that nature, the landscape, the walking, is at the heart of my work, and informs the indoor work. But the art world is received (mainly) 'indoors' and I do have a desire to present real work in public time and space, as opposed to photos, maps, texts, which are by definition 'second hand' works, and thus imaginative. For me, the different forms of my work represent freedom and richness — it's not possible to say 'everything' in one way.

GL What is your routine during a walk? Where do you usually sleep and eat?

RL On a wilderness walk I walk all day carrying lightweight food, cook by campfire or camp stove, and sleep in a tent. On a road walk I walk all day, eat from shops, cafes or pubs along the way, and sleep either in my tent or wayside inns, hotels etc.

GL Do you work continuously or do you return home and remain there for some time after making a work?

RL I need to be at home as much as I need to travel.

INTERVIEW

between Mario Codognato and **Richard Long**, 1997

MC Your walks in the landscape and the sculptures made along the way, and recorded in photographs, maps or text works, are an essential element in your art. How do you chose your itineraries?

RL For many different reasons. I may have a precise, pre-planned idea for a road walk. Alternatively, especially on a wilderness walk, I will encounter places and experiences which are new and not predictable, and my ideas could change along the way. I like to use both ways of working. Sometimes I go to familiar places like Dartmoor, specifically using my own experience and history for the work, and other times I could go to a very unknown (to me) place like Tierra del Fuego. Good places like that usually make good walks.

I had a particular desire in the seventies to make my circles, and also the straight hundred mile walks, in different types of landscapes around the world.

MC Circles in most cultures are the symbolic representation of the fundamental elements of nature, like the sun or the moon, of the divine, of the recurring of time, of infinity. Lines often indicate continuation in space, distance, communication, movement. Why have you chosen these forms so often?

RL I made my first circle in 1966 without thought, although in hindsight I know it is potent for all the reasons you describe. A circle is beautiful, powerful, but also neutral and abstract. I realized it could serve as a constant form, always with new content. A circle could carry a different walking idea, or collection of stones, or be in a different place, each time.

A circle suits the anonymous but man-made character of my work. My ideas can be expressed better without the artistic clutter of idiosyncratic, invented shapes.

Circles and lines are also practical, they are easy to make. A line can be made just by aligning features in the landscape, and it can point to the horizon, into the distance.

The particular characteristics of each place determine which is most appropriate, a circle or a line. It's always obvious. A circle is more contemplative, focused, like a stopping place, and a line is more like the walk itself. On a twelve day walk in the mountains of Ladakh in 1984 I made a sculpture – marks along the way – literally on the line of the walk and the footpath. Walking within walking.

MC Quite a few of your works are transient. A line made by walking on the grass disappears after a time. Often your mud works are cancelled at the end of an exhibition. What is your idea of duration and eternity?

RL On a beach in Cornwall in 1970 I made a spiral of seaweed below the tide line. I liked the idea that my work, lasting only a tide, was interposed between past and future patterns of seaweed of infinite variation, made by natural and lunar forces, repeating for millions of years.

Often the transient is closely related to the eternal in nature.

In an ideal art world, I would prefer some of my mud works, especially the large majestic ones, to remain after an exhibition.

MC For quite a few years, I have been lucky enough to witness the way you install your works in exhibition spaces. You seem to give, almost magically, a sort of order from chaos. The viscosity of mud – the union of water and earth – becomes a vortex of energy which gives birth to the most beautiful wall work. An ordinary pile of stones becomes an amazing sculpture which invites contemplation and meditation. What are the roles of chance and time in the execution of your works?

RL Particularly with the mud works, time and chance make them, in a way. Because they show the nature of water as well as mud – the wateriness of it – I have to work quickly to make the energy for the splashes. The image is both my actual hand marks but also the chance splashes which are determined by the speed of my hand, the viscosity of the mud, and gravity. There is the scale of the work both as a whole image and also the micro-scale of the splashes with their cosmic variety. I like being able to use and show the nature of chance in this part of my work.

Time is the fourth dimension in my art. It is often the subject of a walk – time as the measurement of distance, of walking speed, or of terrain, or of fatigue, or of carrying stones, or of one stone to another.

The sculptures contain the geological time of the stones.

MC Global warming and the devastation of many environments is more and more the concern of the general public and our culture. Many people see your work as about ecology as well. How do you define your art, and what is your view about this aspect of it?

RL My work is just art, not 'political' art, but I do believe – now more than years ago – that I have to be responsible, both in my work and in my general life, like anyone.

I first chose landscape so as to use the dimension of distance to make a work of art by walking. That was on Exmoor. I was intuitively attracted to such relatively empty, non-urban landscapes partly because they were the best places to realize my ideas, but also because such places gave me pleasure to be in. They had a spiritual dimension which was also important for the work. So my work comes from a desire to be in a dynamic, creative and engaged harmony with nature, and not actually from any political or ecological motives.

I believe if it is good enough, if a love and respect for nature comes through, if only indirectly, then that is my statement of intent. One of the main themes of my work is water, and water is more important than technology.

(Still waters run deep)

Making art in the type of landscapes which still cover most of our planet gives me quite an optimistic and realistic view of the world. I think my work is almost nothing, its just about being there – anywhere – being a witness from the point of view of an artist.

The landscape is a limitless arena where I can engage with those things that have the most meaning and interest for me, like rivers, camping, the weather, measuring countries by my own footsteps, mud, moving a few stones around, and being in places of profound experience.

RICHARD LONG MARCH 19–22 1969

A WALKING TOUR IN THE BERNER OBERLAND

A PRINTED POSTER WORK FOR THE EXHIBITION: WHEN ATTITUDES BECOME FORM BERN 1969

TURF CIRCLE MUSEUM HAUS LANGE KREFELD 1969

CIRCLE IN THE ANDES 1972

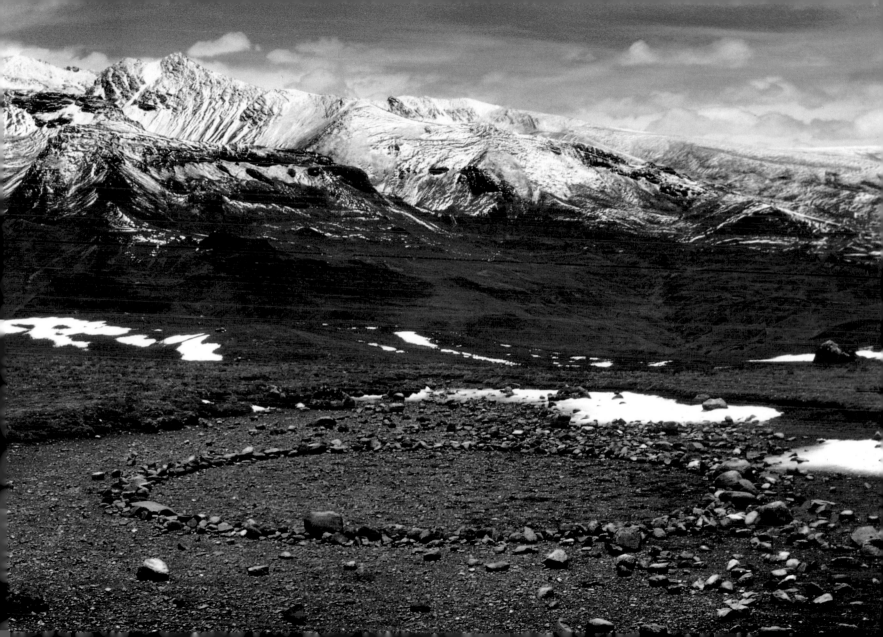

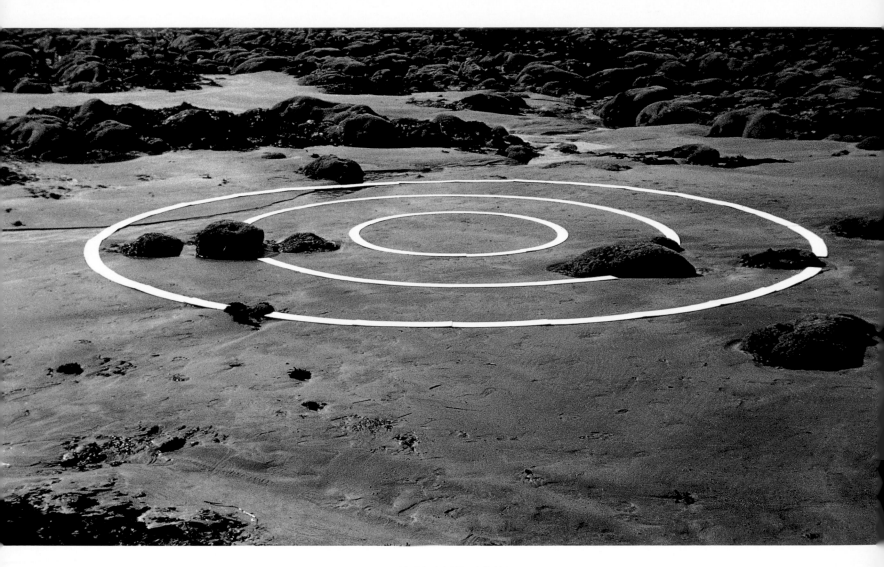

IRELAND 1967

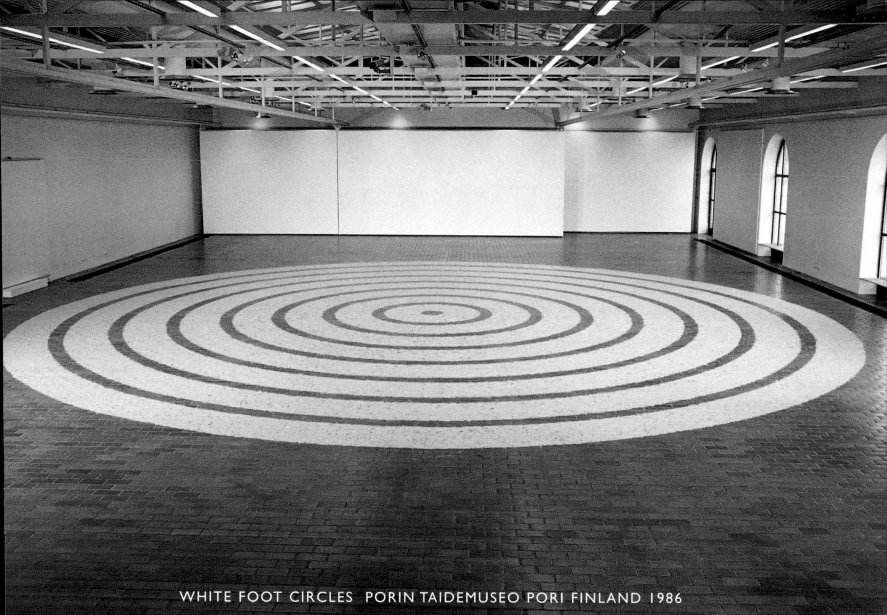

WHITE FOOT CIRCLES PORIN TAIDEMUSEO PORI FINLAND 1986

THE STONES
INK SLOWLY
WITH THE MELTING SNOW
OF SUMMER

ALONG A FOUR DAY WALK IN NORWAY 1973

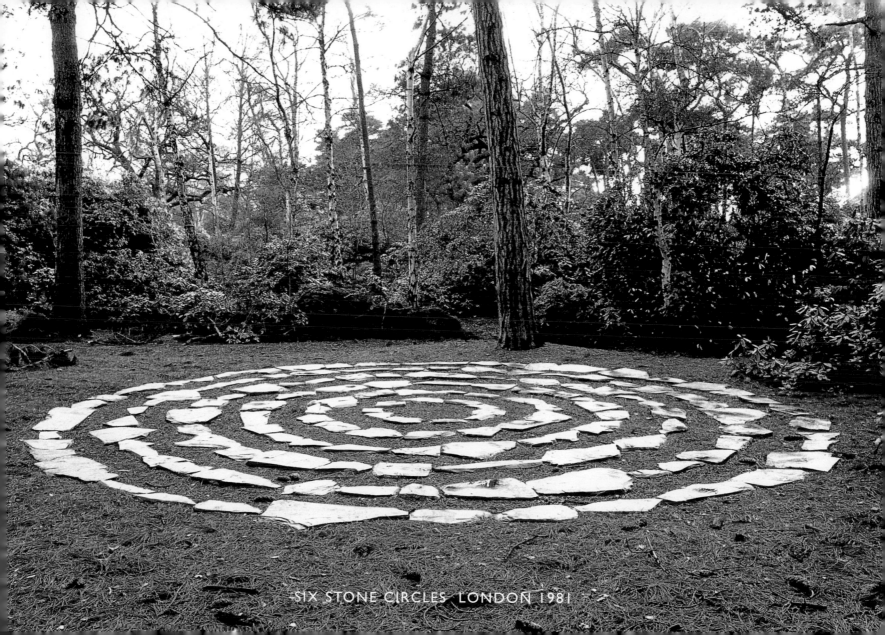

SIX STONE CIRCLES· LONDON 1981

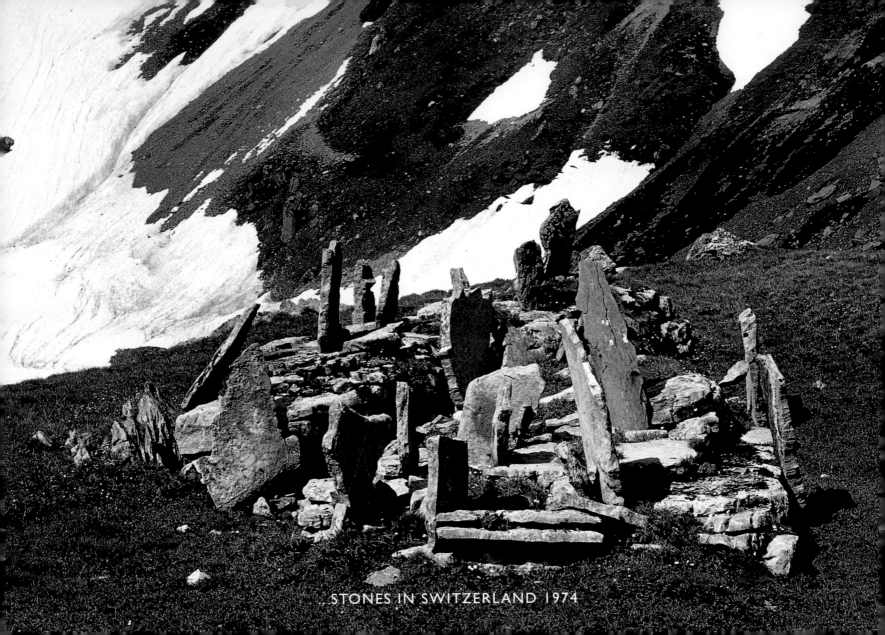
STONES IN SWITZERLAND 1974

WHERE THE WALK MEETS THE PLACE A SIX DAY WALK IN THE HOGGAR THE SAHARA 1988

CORNWALL CARRARA LINE
KONRAD FISCHER DÜSSELDORF 1988

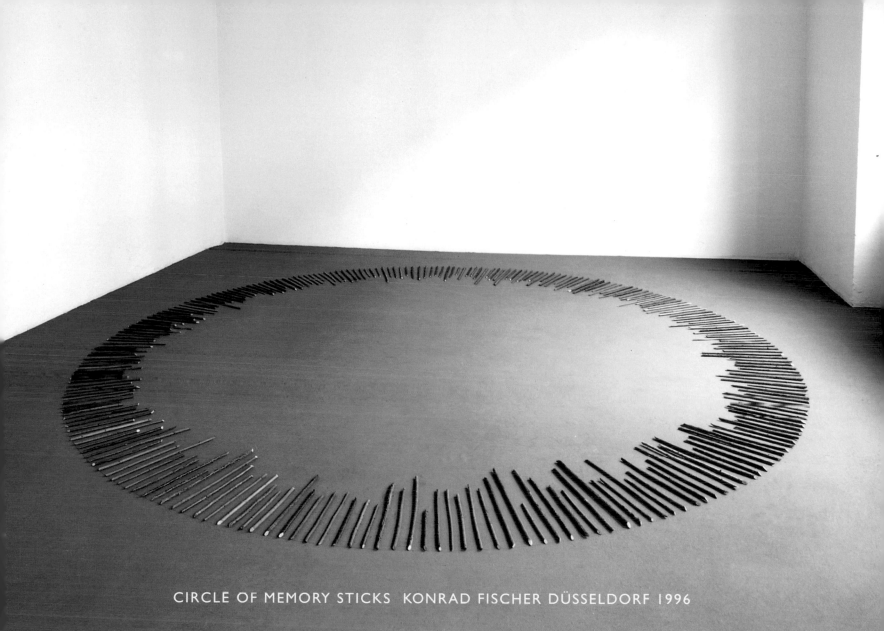

CIRCLE OF MEMORY STICKS KONRAD FISCHER DÜSSELDORF 1996

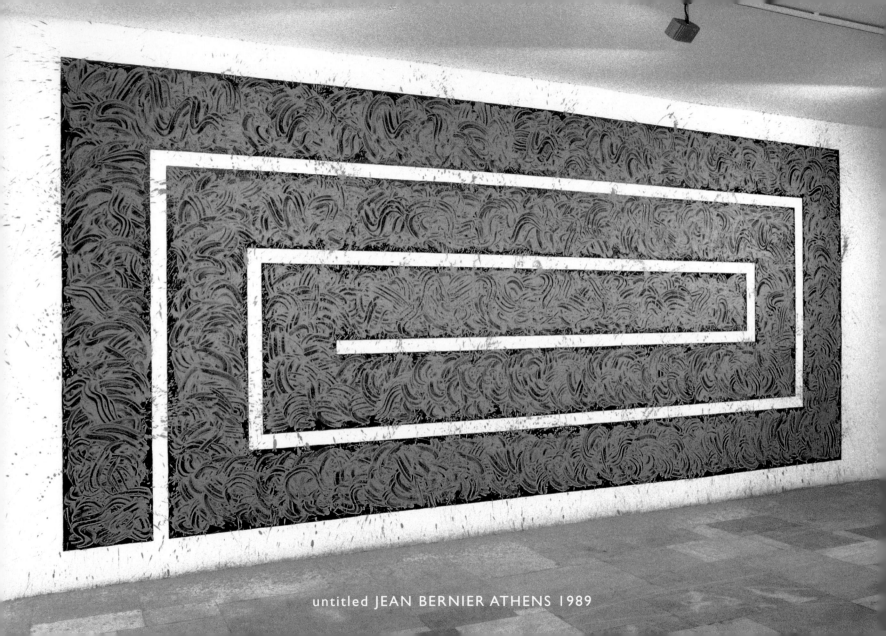

untitled JEAN BERNIER ATHENS 1989

RIVER AVON MUD CIRCLE
JEAN BERNIER ATHENS 1992

WATERLINES

EACH DAY A WATERLINE
POURED FROM MY WATER BOTTLE
ALONG THE WALKING LINE

FROM THE ATLANTIC SHORE TO THE MEDITERRANEAN SHORE
A 560 MILE WALK IN 20½ DAYS ACROSS PORTUGAL AND SPAIN

1989

DUSTLINES

KICKING UP A LINE OF DUST EACH DAY ALONG THE WALKING LINE

A 7 DAY WALK ON THE EAST BANK OF THE RIO GRANDE

EL CAMINO REAL NEW MEXICO 1995

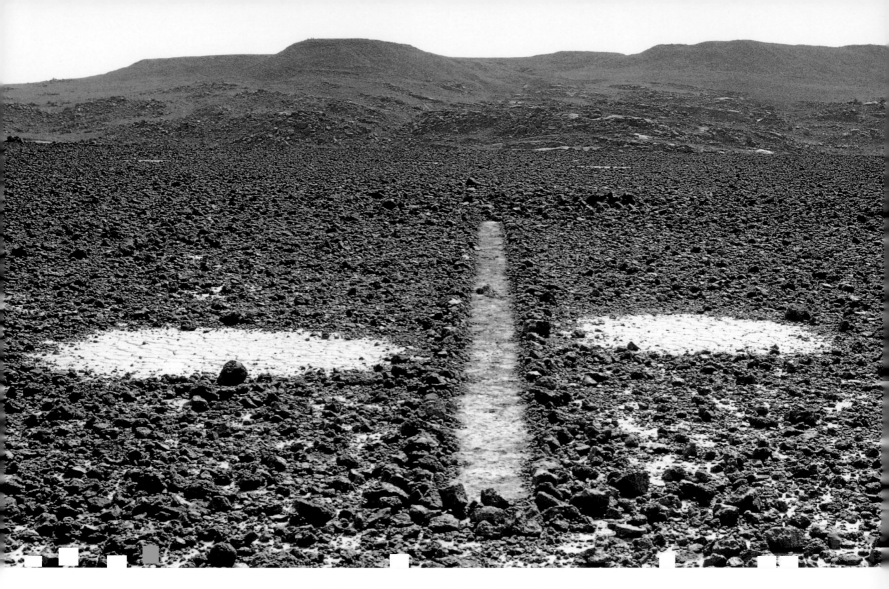

CROSSING MARKS THE SAHARA 1988

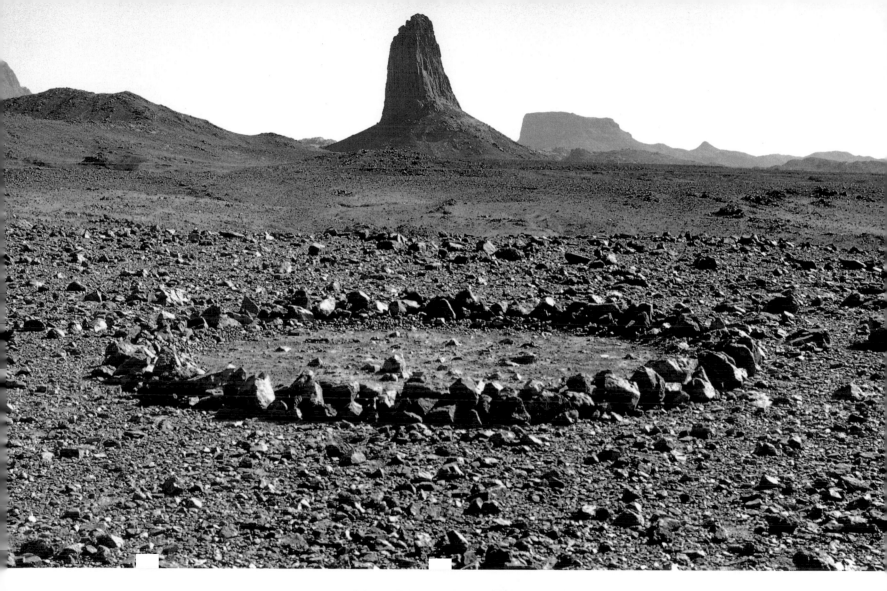

SAHARA CIRCLE 1988

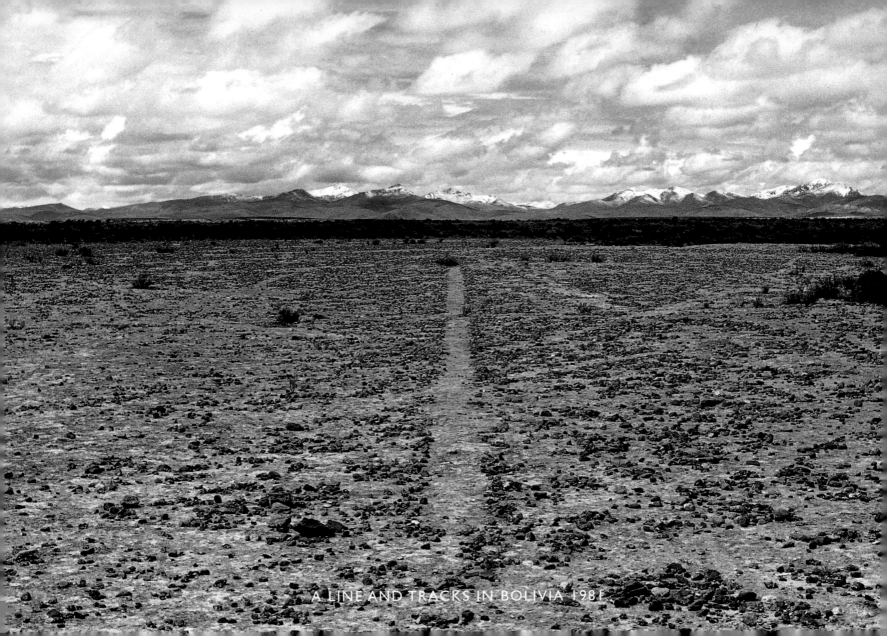

A LINE AND TRACKS IN BOLIVIA 1981

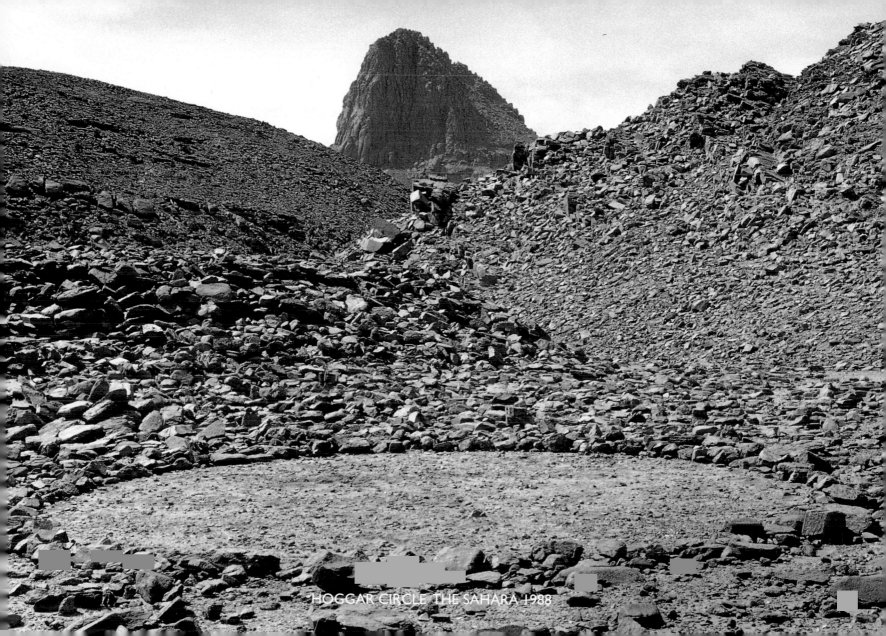

HOGGAR CIRCLE THE SAHARA 1988

WIND STONES

LONG POINTED STONES

SCATTERED ALONG A 15 DAY WALK IN LAPPLAND
207 STONES TURNED TO POINT INTO THE WIND

1985

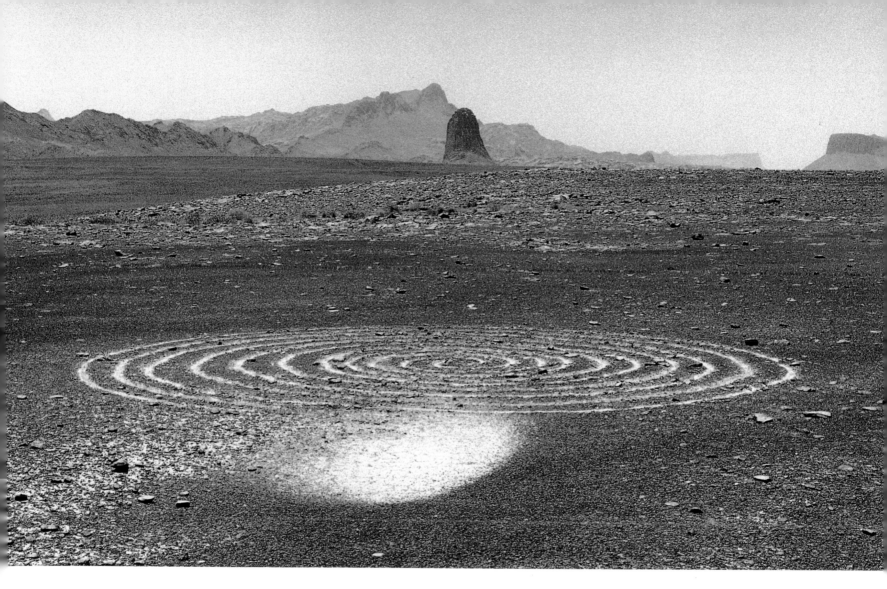

WHIRLWIND SPIRAL THE SAHARA 1988

WIND CIRCLE A SOUTHWARD WALK OF 220 MILES IN 14 DAYS ACROSS THE MIDDLE OF ICELAND 1994

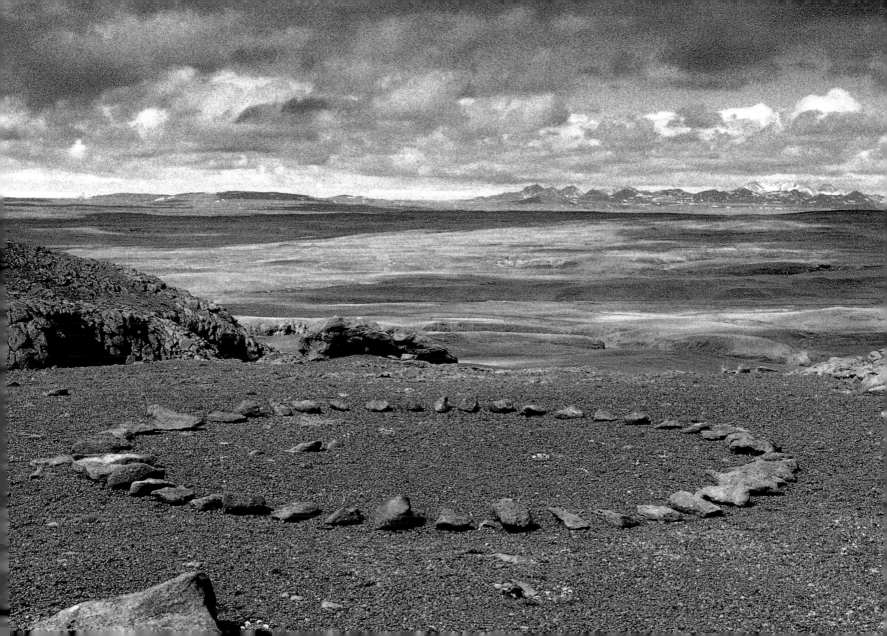

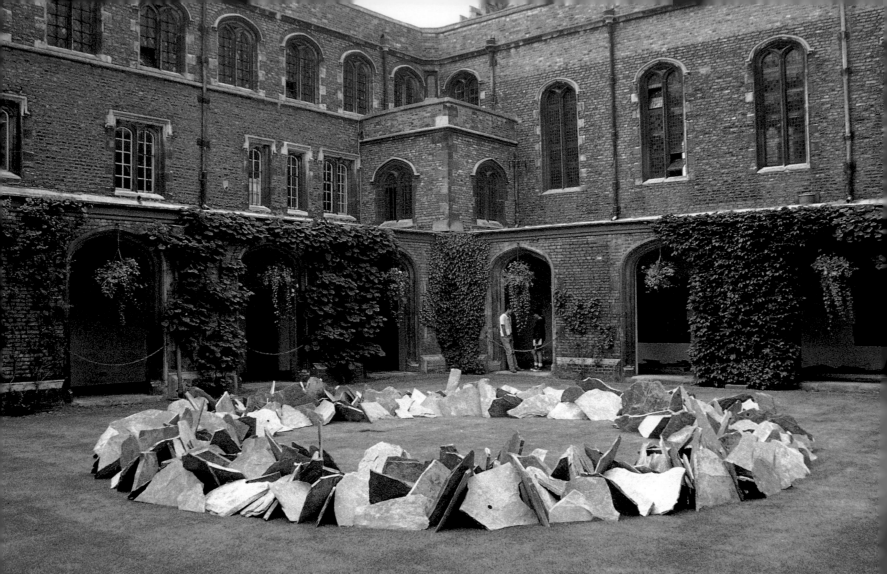

ORCADIAN CIRCLE JESUS COLLEGE CAMBRIDGE 1992

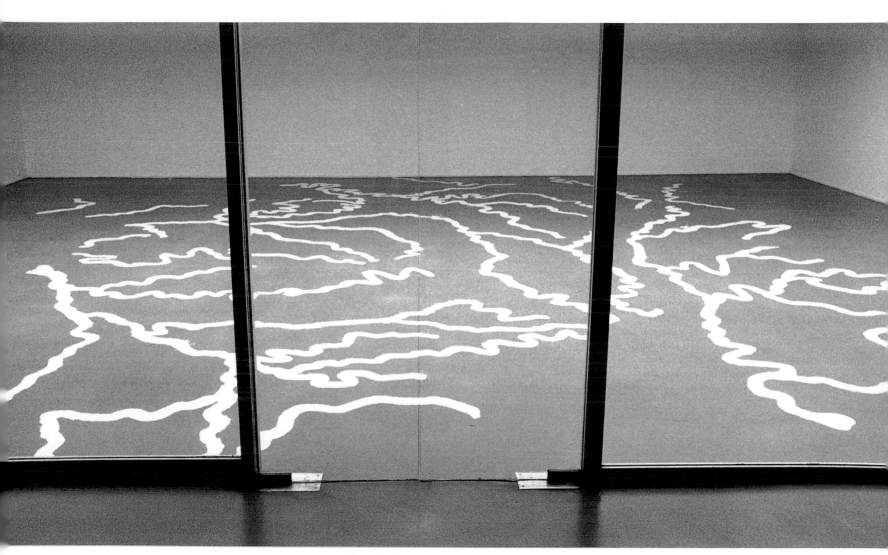

THE RIVERS OF FRANCE
ARC, MUSÉE D'ART MODERNE DE LA VILLE DE PARIS 1993

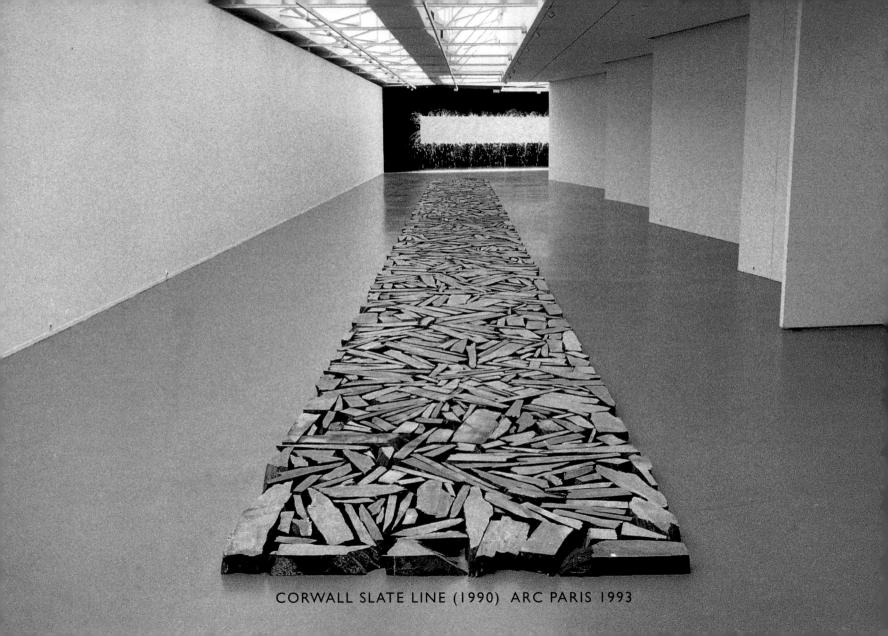

CORWALL SLATE LINE (1990) ARC PARIS 1993

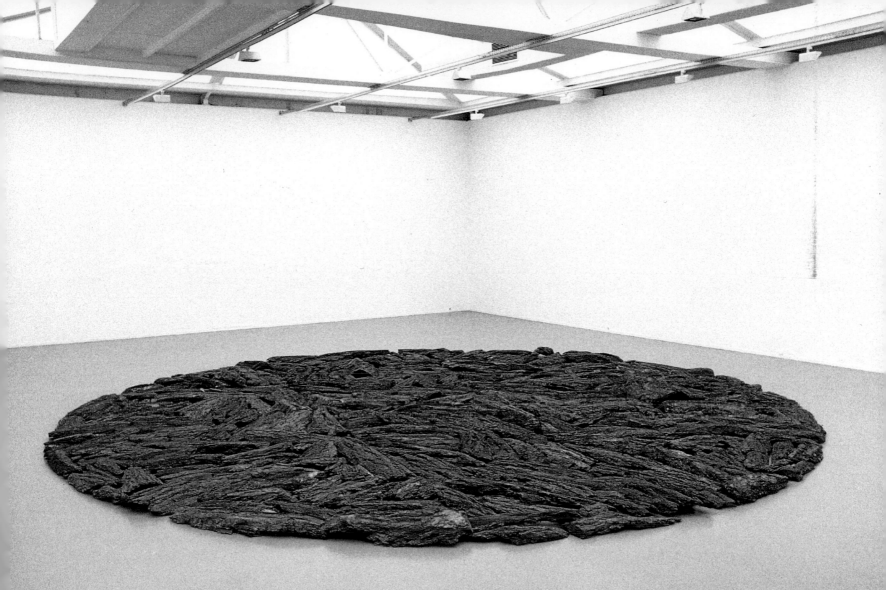

BARK CIRCLE ARC PARIS 1993

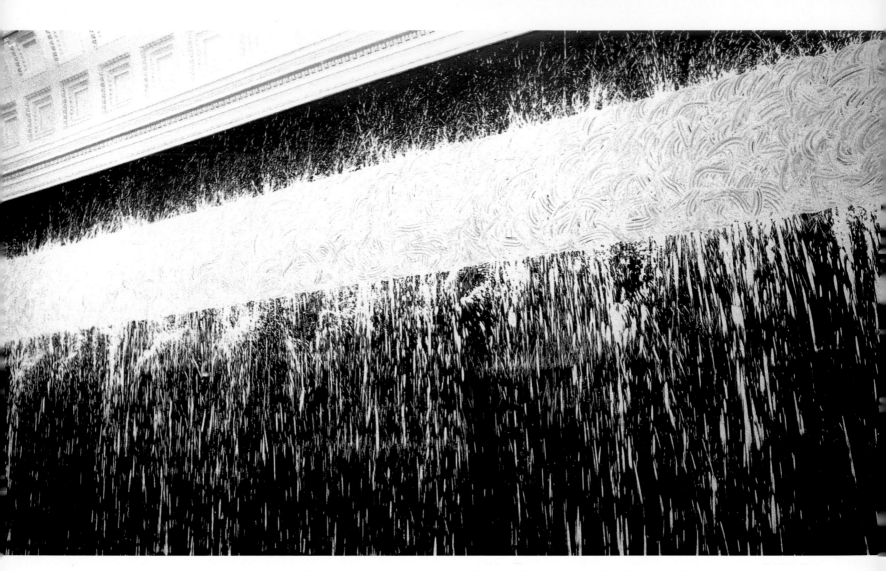

MUDDY WATER LINE PALAZZO DELLE ESPOSIZIONI ROMA 1994

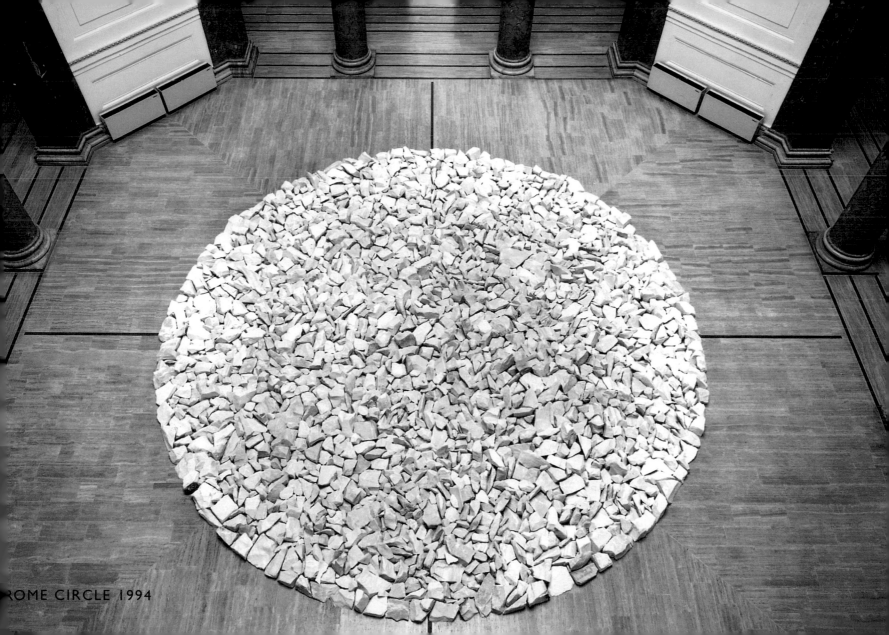

ROME CIRCLE 1994

ROMULUS CIRCLE AND REMUS CIRCLE ROMA 1994

PIETRA DI LUSERNA LINE (1991) ROMA 1994

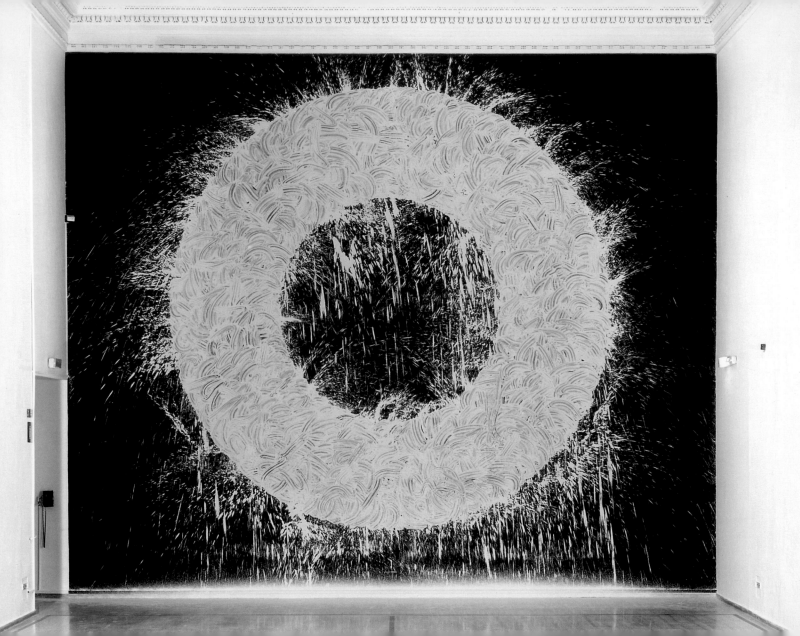

MUDDY
WATER
CIRCLES

ROMA 19

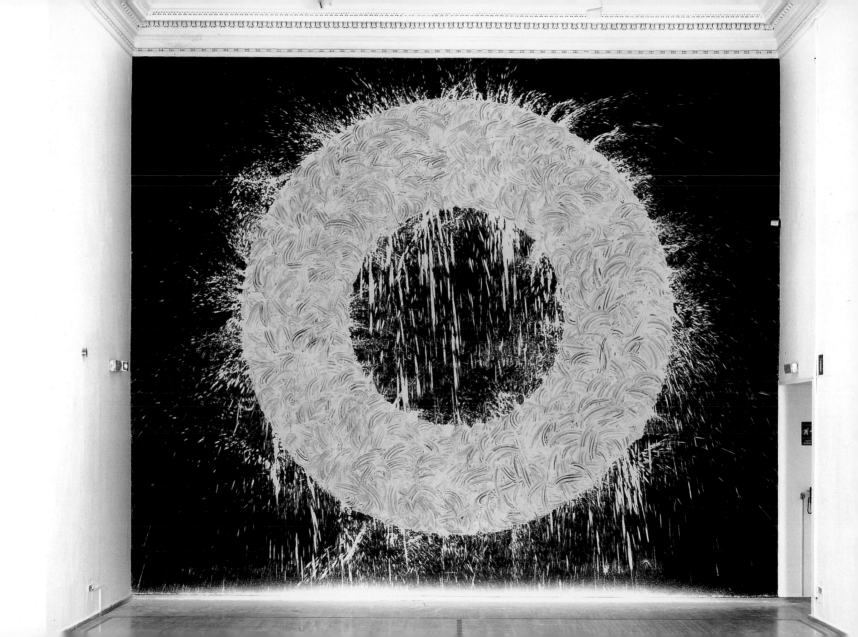

MUD WALK

A 184 MILE WALK FROM THE MOUTH OF THE RIVER AVON
TO A SOURCE OF THE RIVER MERSEY
CASTING A HANDFUL OF RIVER AVON TIDAL MUD
INTO EACH OF THE RIVERS THAMES SEVERN TRENT AND MERSEY
ALONG THE WAY

ENGLAND 1987

W A T E R S H E D

RIVER AVON TO RIVER THAMES

A WALK OF 120 MILES IN 39 HOURS FROM BRISTOL BRIDGE TO LONDON BRIDGE

A DAY NIGHT DAY NIGHT WALK

ENGLAND 1992

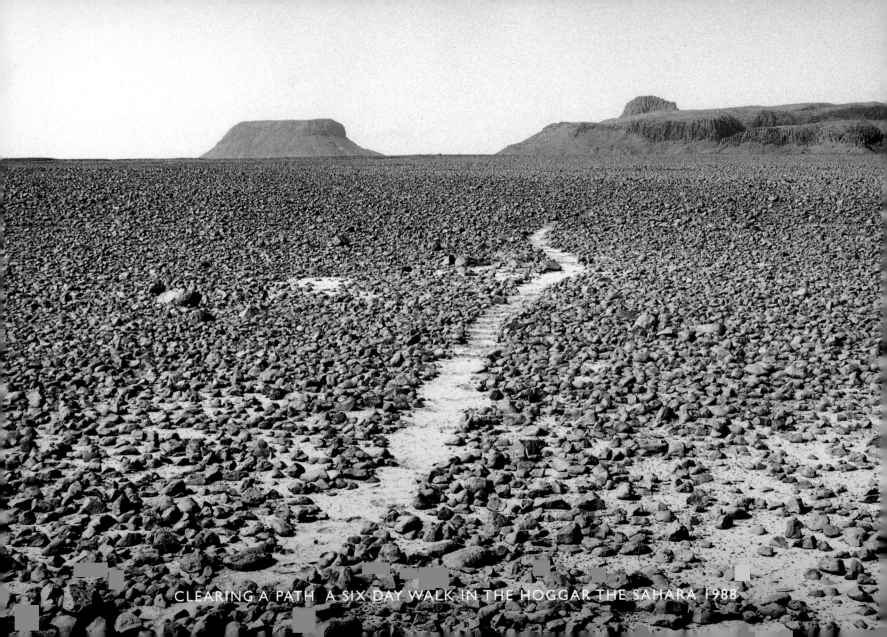

CLEARING A PATH A SIX DAY WALK IN THE HOGGAR THE SAHARA 1988

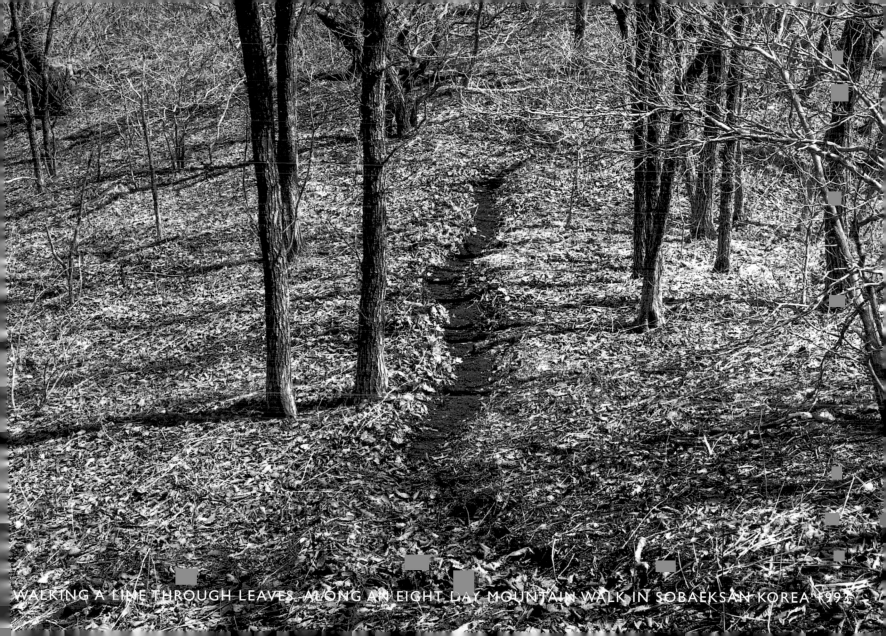

WALKING A LINE THROUGH LEAVES. ALONG AN EIGHT DAY MOUNTAIN WALK IN SOBAEKSAN KOREA 1993

SAHARA STANDING STONE LINE 1988

DRY WALK

113 WALKING MILES
BETWEEN ONE SHOWER OF RAIN AND THE NEXT

AVON ENGLAND 1989

RAIN DRUMMING ON THE TENT

SEVEN DAYS WALKING AND SEVEN NIGHTS CAMPING
IN THE MOUNTAINS OF CONNEMARA AND SOUTH MAYO
A SOUND FROM EACH OF THE CAMPSITES ALONG THE WAY

RAIN DRUMMING ON THE TENT

THE WILD FLAPPING OF THE TENT IN THE WIND

A GURGLING STREAM

ABBEY BELLS

THE LIGHT HISS OF MIST ON THE TENT

A RUSHING RIVER

THE LARK IN THE MORNING

IRELAND EARLY SPRING 1997

STONES IN THE MIST ON OUGHTY CRAGGY IRELAND 1997

OLD YEAR NEW YEAR WALK

THE LAST TWELVE HOURS OF 1992 – THE FIRST TWELVE HOURS OF 1993

A WALK OF 80 MILES IN 24 HOURS

MIDNIGHT NEAR NYTHE ON KING'S SEDGE MOOR SOMERSET ENGLAND

MIDSUMMER DAY'S WALK

ON GLASTONBURY TOR AT NOON

A WALK OF 59 MILES BETWEEN SUNRISE AND SUNSET

ENGLAND 1994

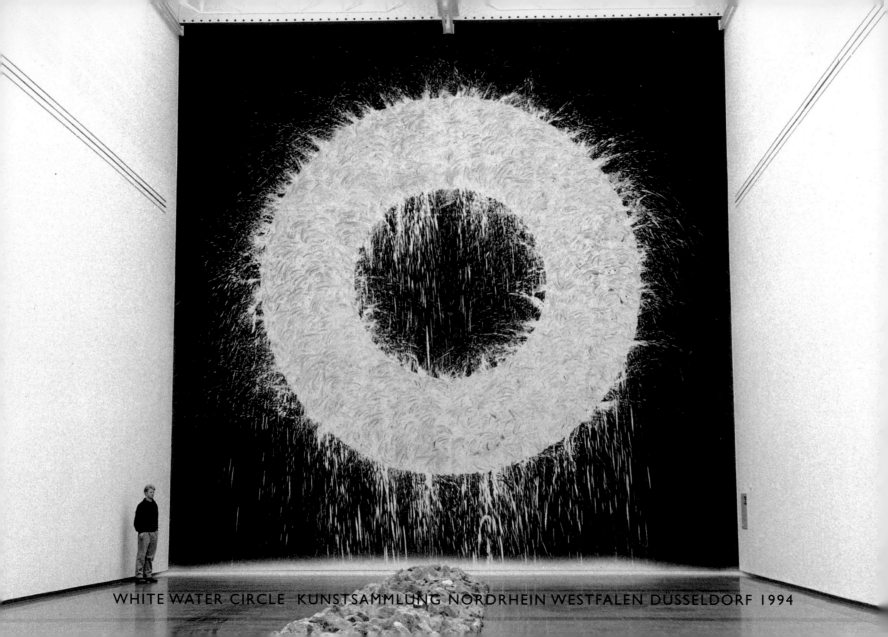

WHITE WATER CIRCLE KUNSTSAMMLUNG NORDRHEIN WESTFALEN DÜSSELDORF 1994

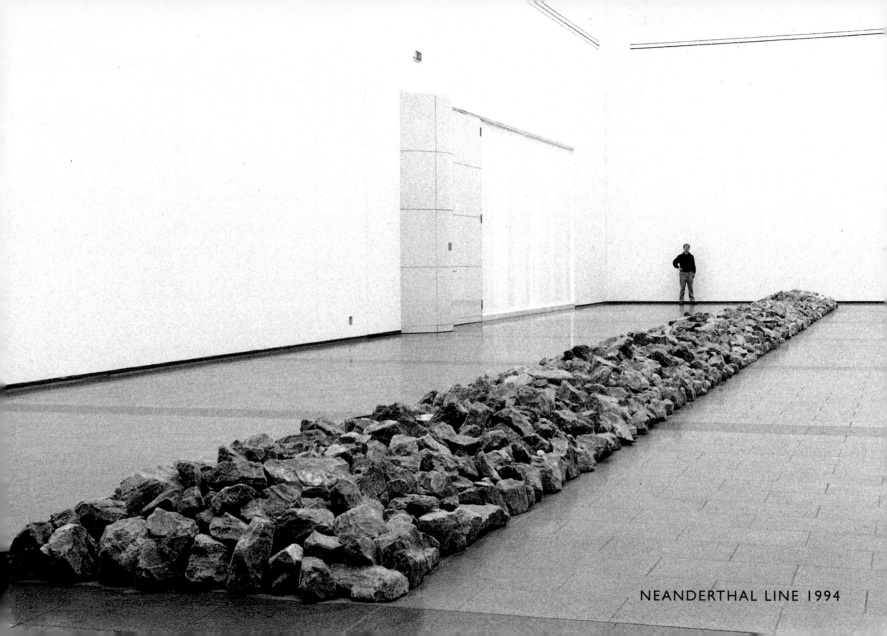

NEANDERTHAL LINE 1994

WHITE RIVER LINE SÃO PAULO BIENAL BRAZIL 1994 (detail)

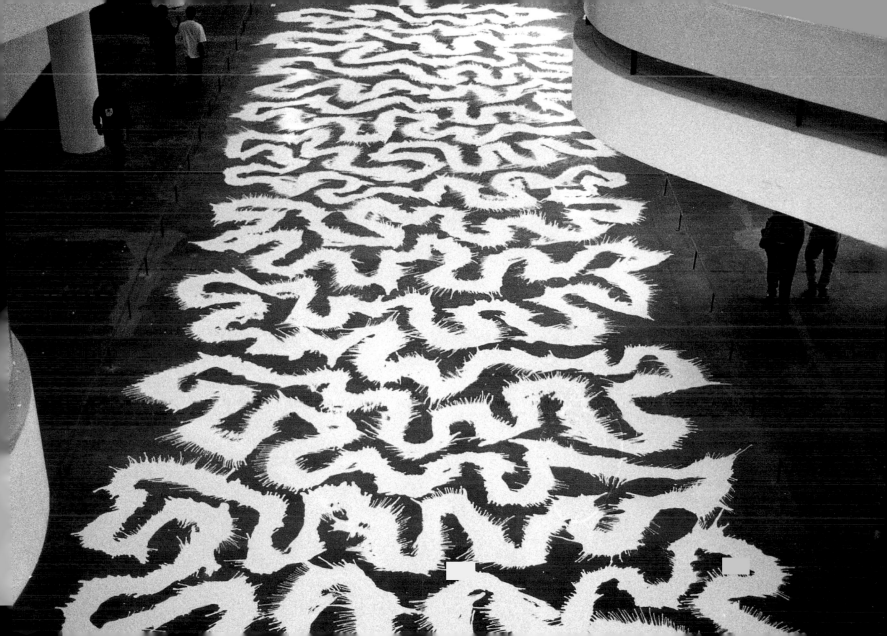

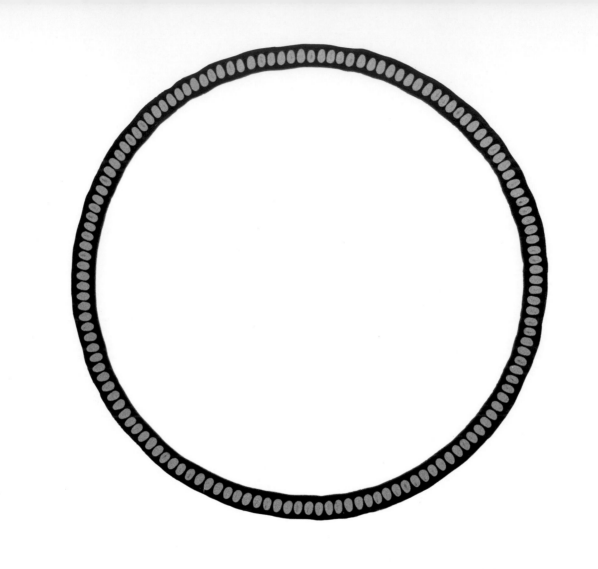

FINGERPRINT CIRCLE THE PIER ARTS CENTRE STROMNESS ORKNEY 1994

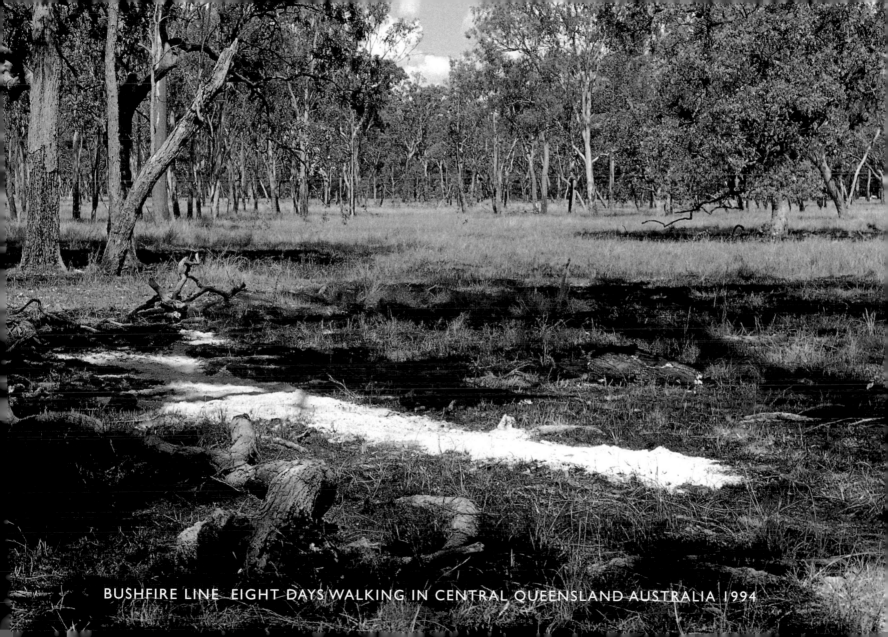

BUSHFIRE LINE EIGHT DAYS WALKING IN CENTRAL QUEENSLAND AUSTRALIA 1994

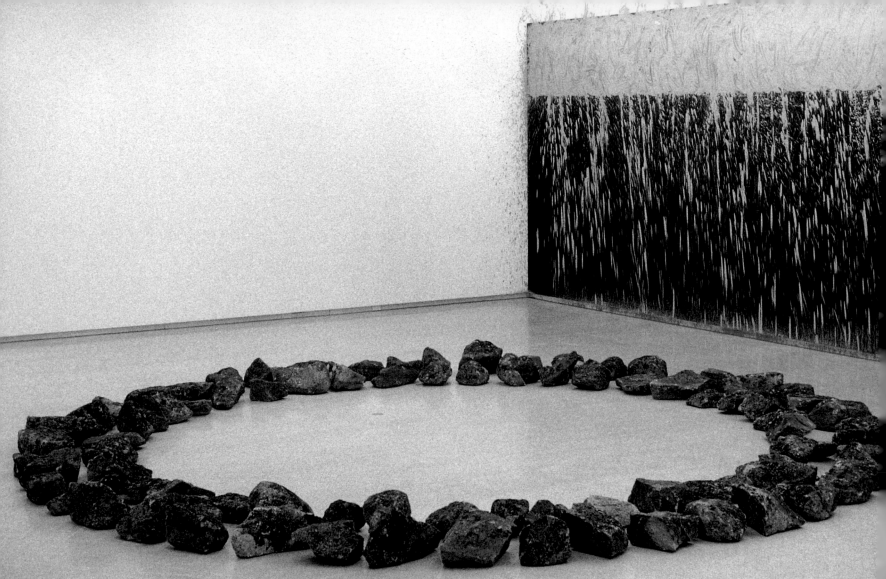

BUSH STONE CIRCLE MUSEUM OF CONTEMPORARY ART SYDNEY 1994

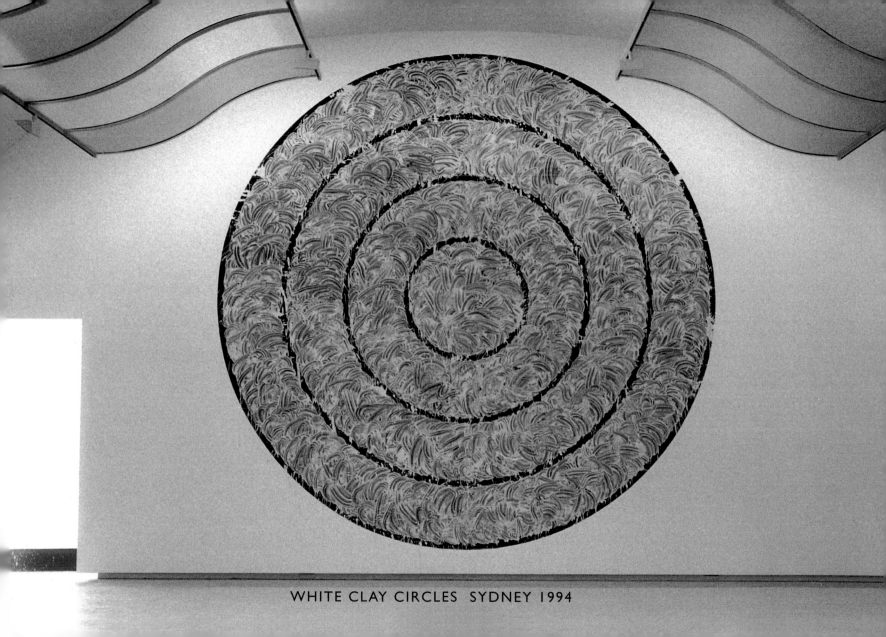

WHITE CLAY CIRCLES SYDNEY 1994

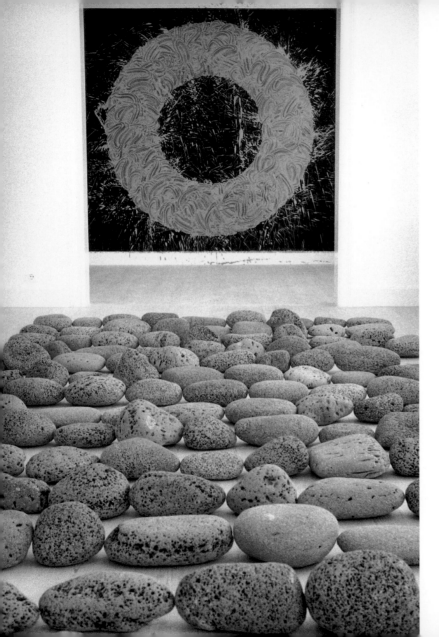

ATLANTIC LAVA LINE
SYNINGARSULAR REYKJAVIK ICELAND 1995

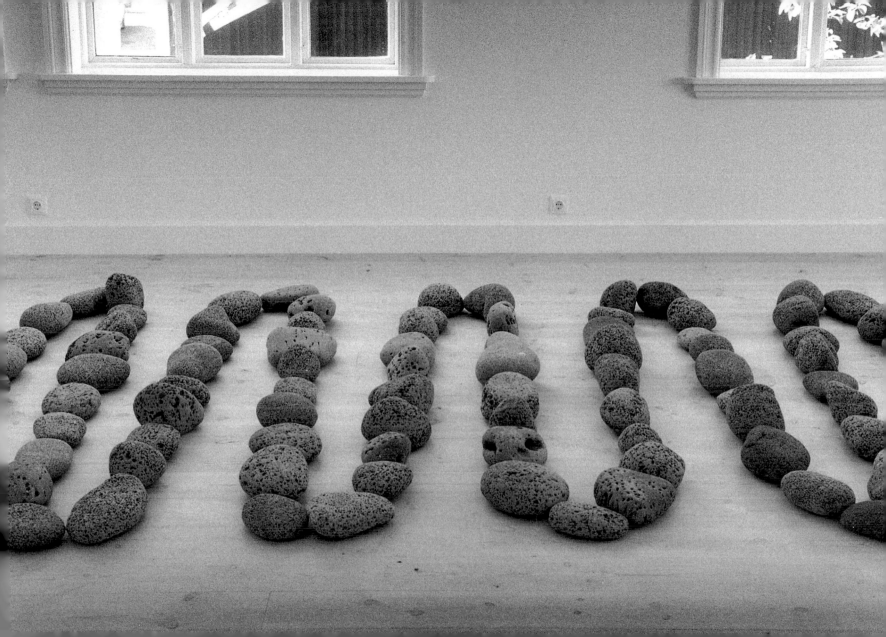

LEAVING THE STONES
A FIVE DAY WALK WITH DOGS ON SPITZBERGEN SVALBARD NORWAY 1995

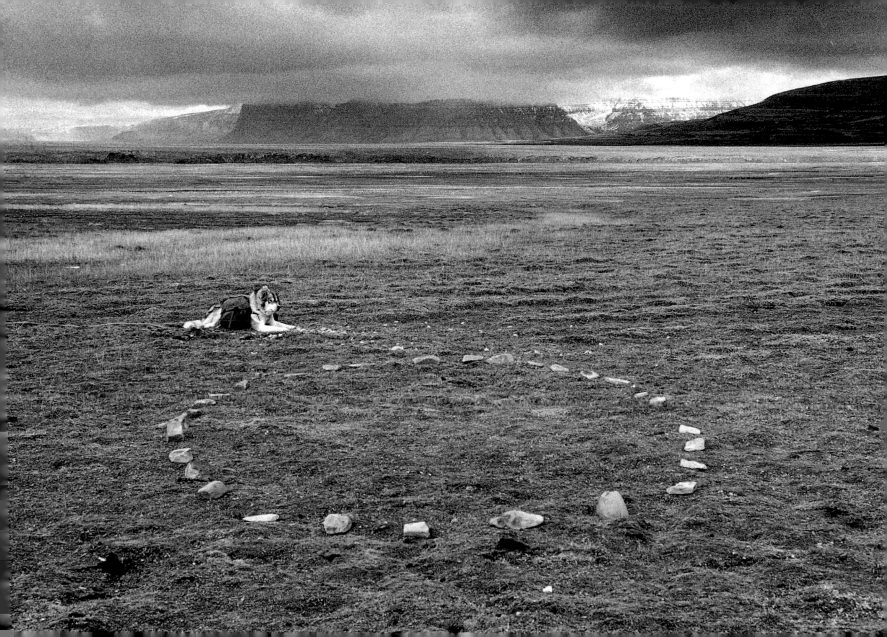

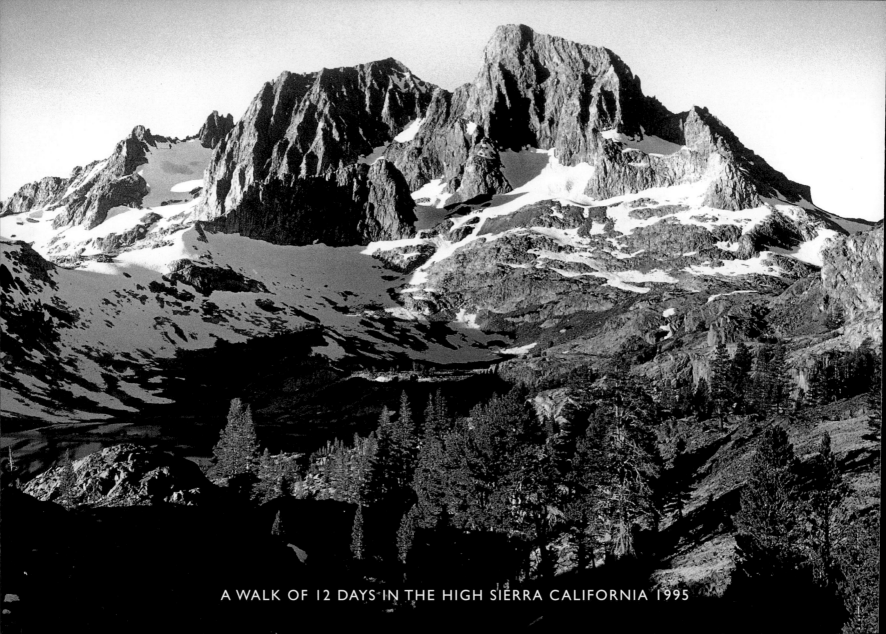

A WALK OF 12 DAYS IN THE HIGH SIERRA CALIFORNIA 1995

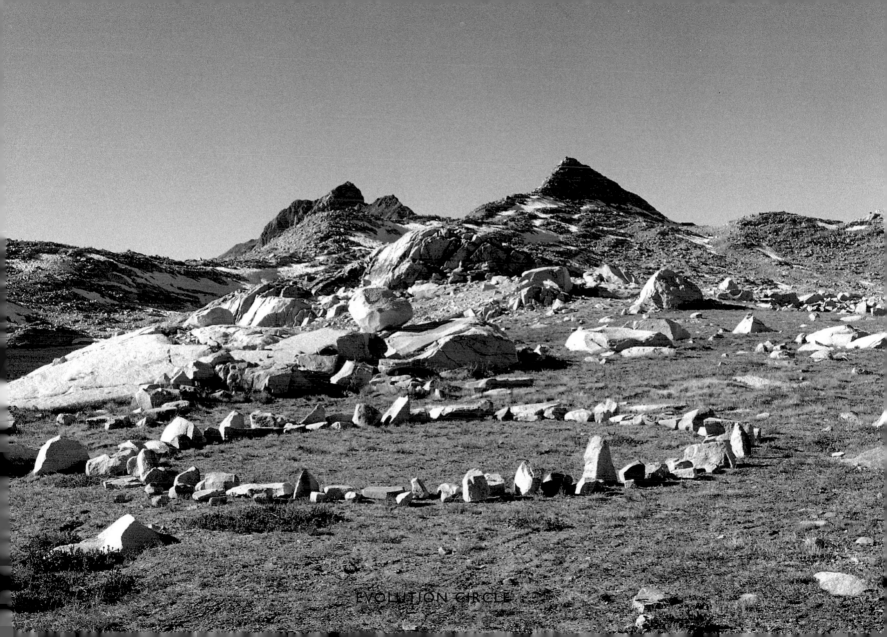

EVOLUTION CIRCLE

HOURS
MILES

A WALK OF 24 HOURS : 82 MILES

A WALK OF 24 MILES IN 82 HOURS

ENGLAND 1996

ALTERNATIVES AND EQUIVALENTS

A FOUR DAY WALK ON DARTMOOR

EITHER SLOW WALKING
OR MEANDERING WALKING
OR STRAIGHT WALKING
OR FAST WALKING

ENGLAND 1996

EAST WEST CIRCLE SETAGAYA ART MUSEUM TOKYO 1996

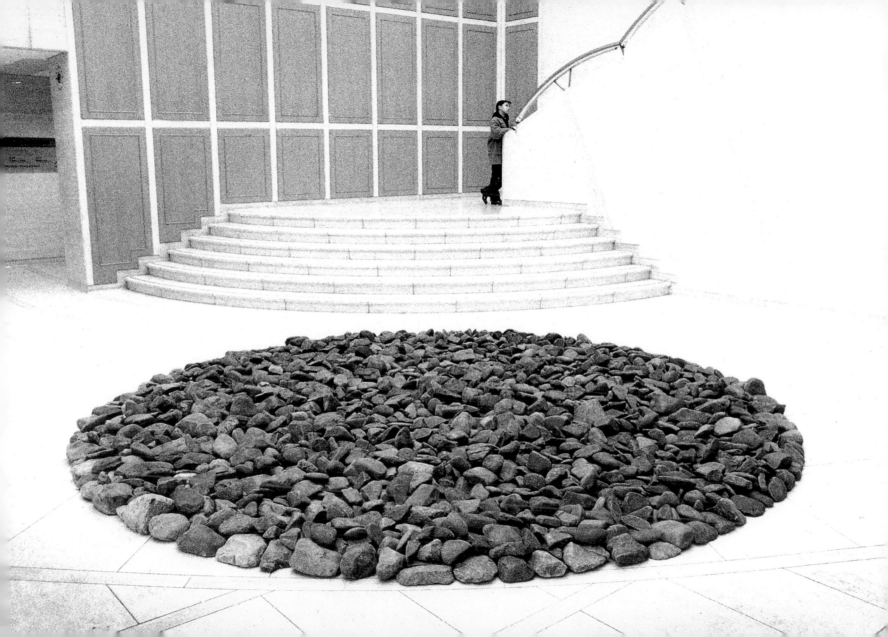

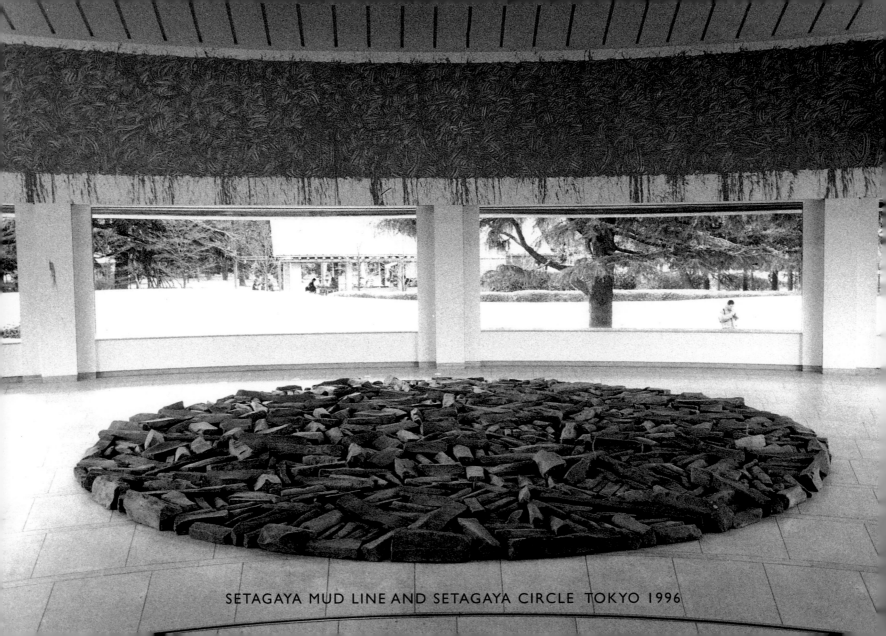

SETAGAYA MUD LINE AND SETAGAYA CIRCLE TOKYO 1996

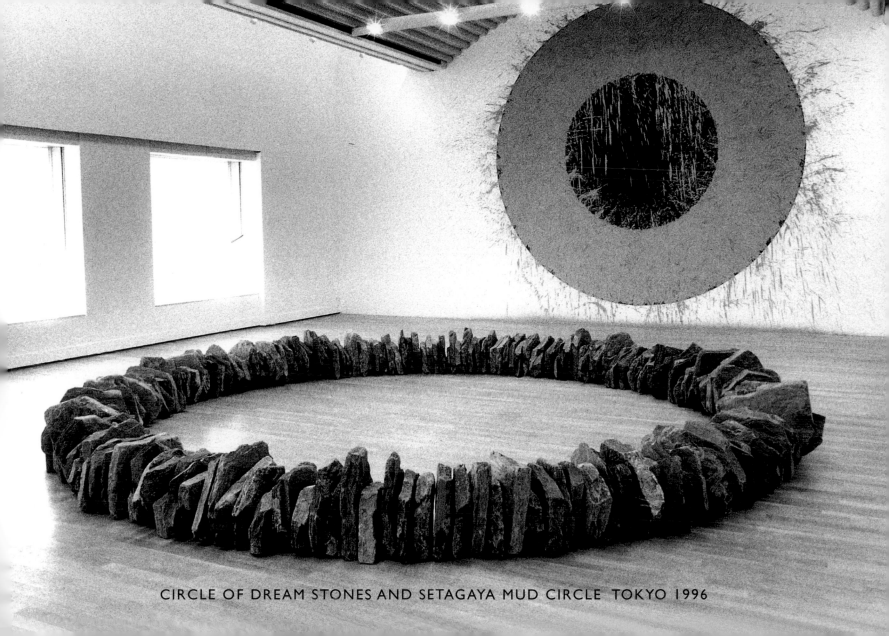

CIRCLE OF DREAM STONES AND SETAGAYA MUD CIRCLE TOKYO 1996

WHITE MUD HAND CIRCLE TOKYO 1996

WATERFALL LINE TOKYO 1996

WALKING TO A LUNAR ECLIPSE

FROM A MIDDAY HIGH TIDE AT AVONMOUTH
A WALK OF 366 MILES IN 8 DAYS
ENDING AT A MIDNIGHT TOTAL ECLIPSE OF THE FULL MOON

A LEAP YEAR WALK ENGLAND 1996

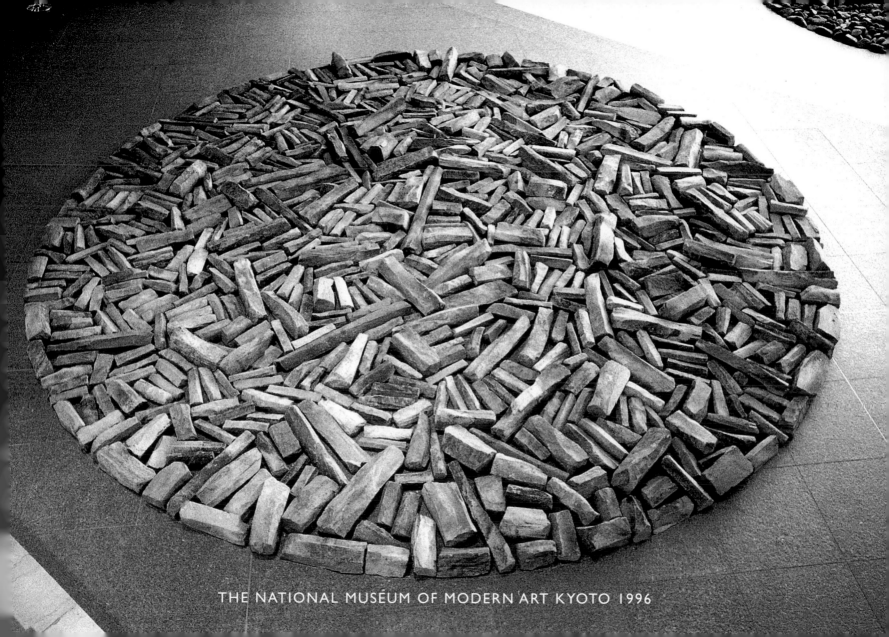

THE NATIONAL MUSÉUM OF MODERN ART KYOTO 1996

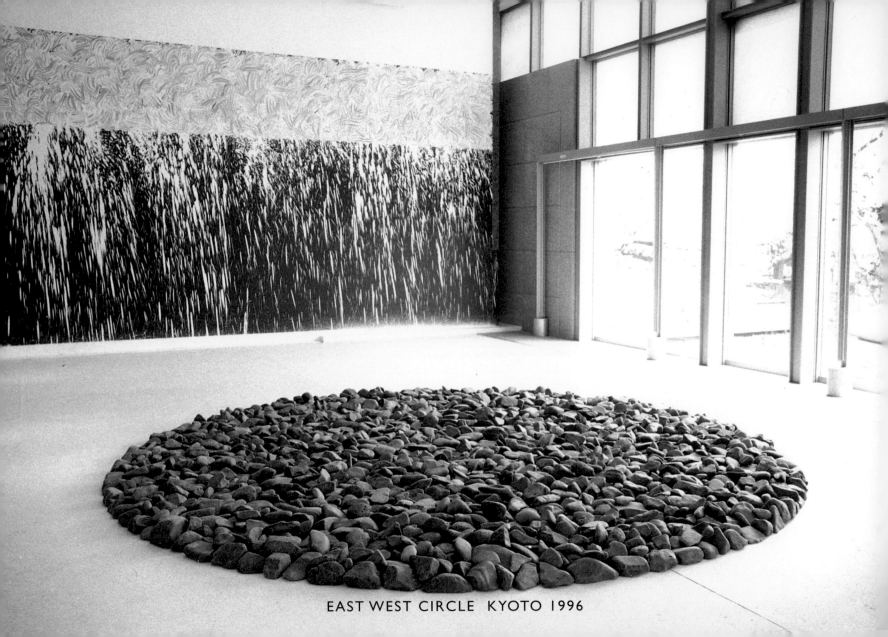

EAST WEST CIRCLE KYOTO 1996

RING OF WATER STONES AND KYOTO MUD CIRCLE KYOTO 1996

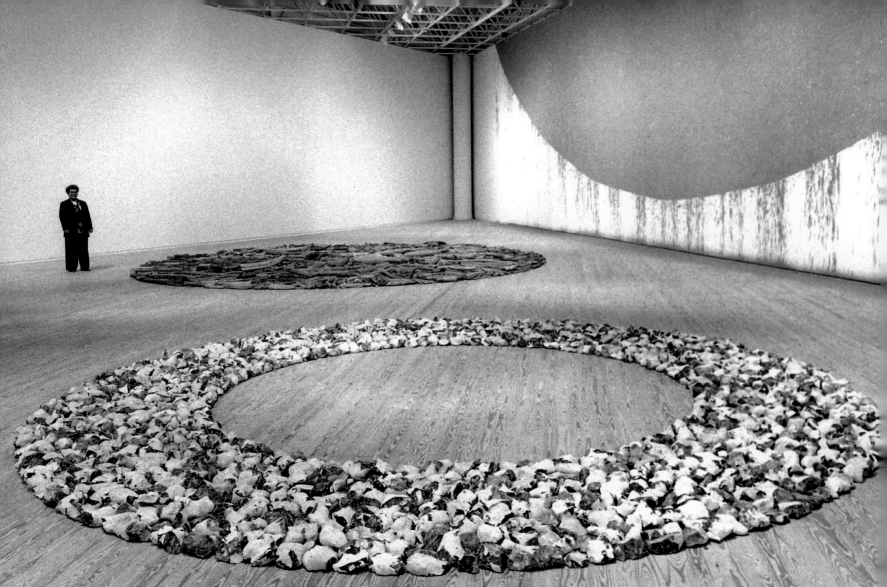

RING OF FLINT AND PUGET SOUND DRIFTWOOD CIRCLE CONTEMPORARY ARTS MUSEUM HOUSTON 1996

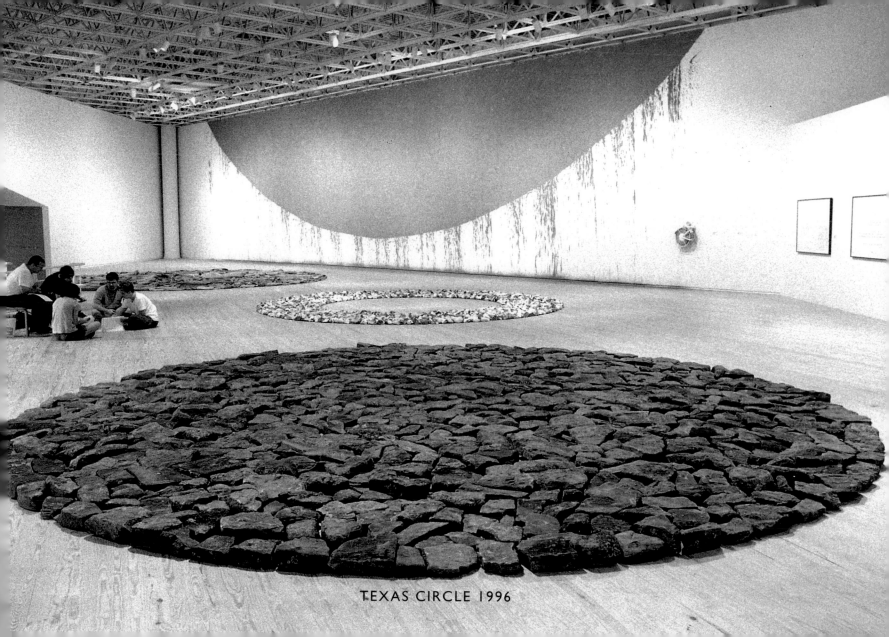

TEXAS CIRCLE 1996

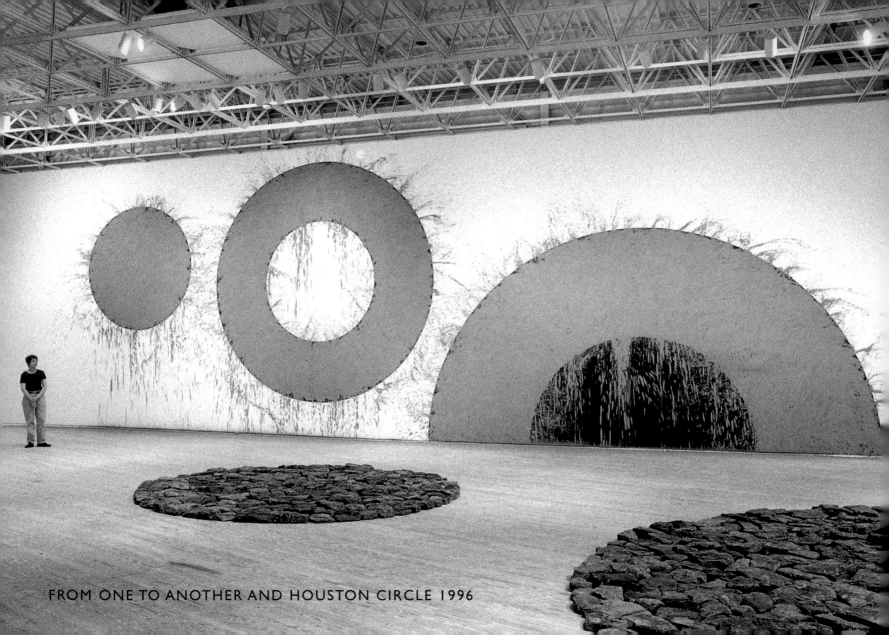

FROM ONE TO ANOTHER AND HOUSTON CIRCLE 1996

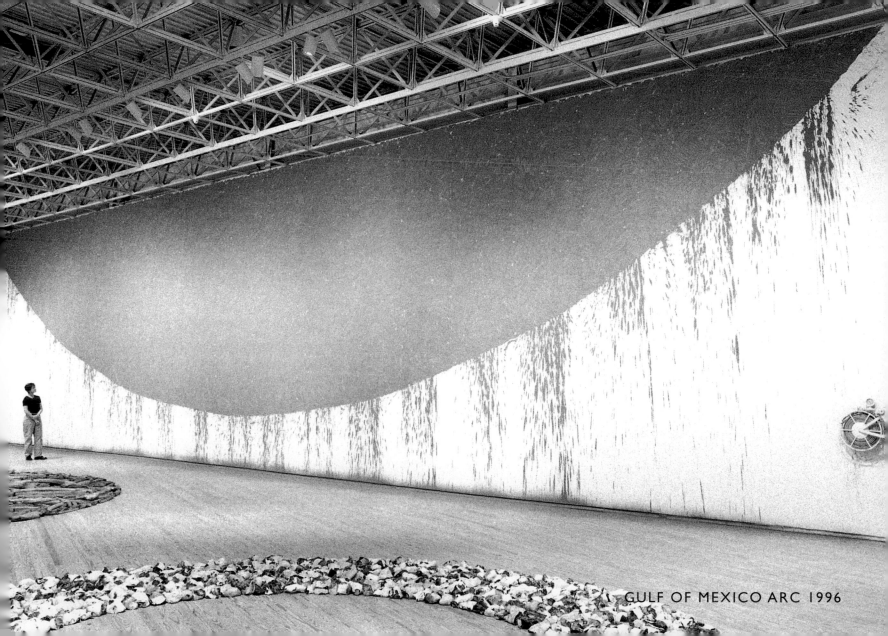

GULF OF MEXICO ARC 1996

ALL IRELAND STONES

A LINE OF 32 STONES RANDOMLY SPACED ALONG A WALKING LINE OF 382 MILES

A 12 DAY ROAD WALK FROM BALTIMORE BEACON ON THE SOUTH COAST
TO THE GIANT'S CAUSEWAY ON THE NORTH COAST

WINTER 1995

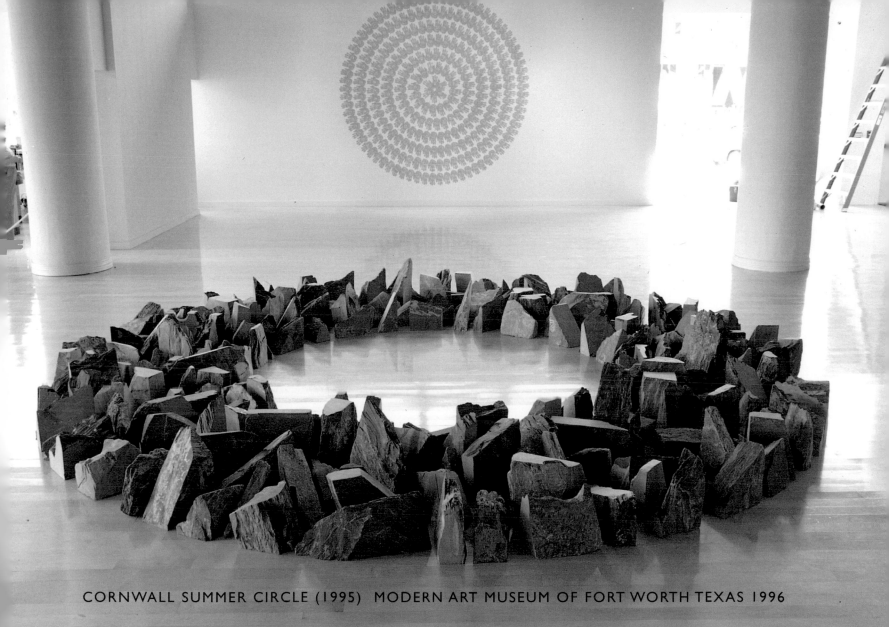

CORNWALL SUMMER CIRCLE (1995) MODERN ART MUSEUM OF FORT WORTH TEXAS 1996

WHITE MUD CIRCLE
ABSTRACTION IN TWENTIETH-CENTURY ART
SOLOMON R. GUGGENHEIM MUSEUM NEW YORK 1996

MUDDY WATER LINE
SOLOMON R. GUGGENHEIM MUSEUM NEW YORK 1996

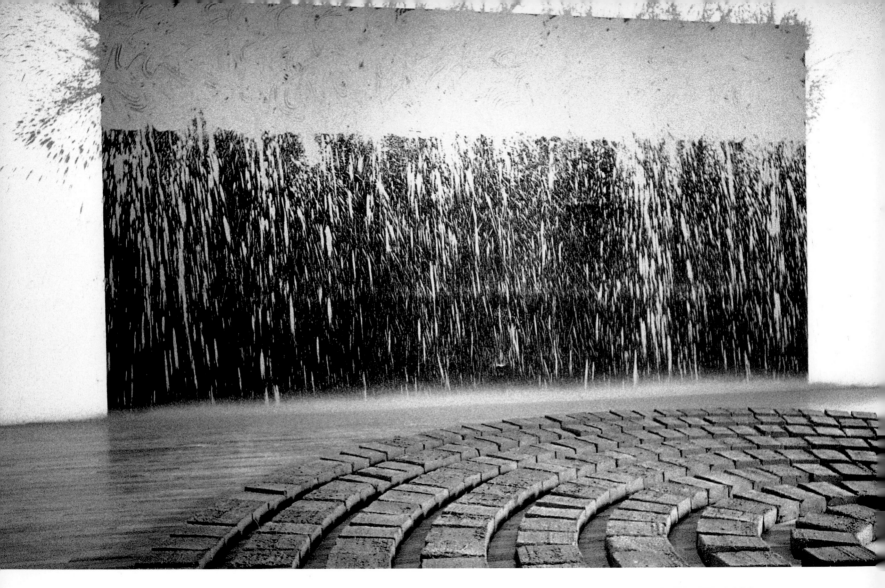

RED MUD WALL THE CENTER FOR CONTEMPORARY ARTS OF SANTA FE 1993

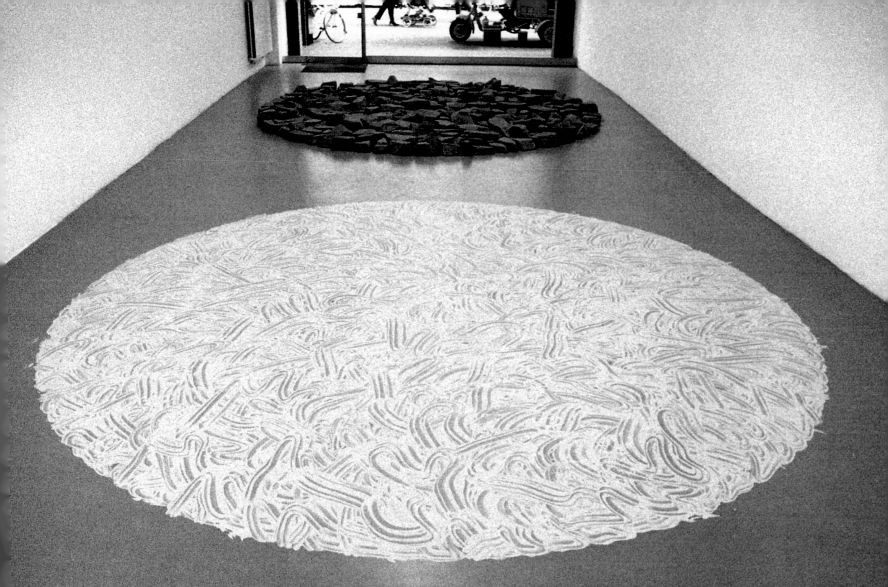

EGGENTAL CIRCLE AND MUDDY HAND CIRCLE GALERIA MUSEO BOLZANO 1996

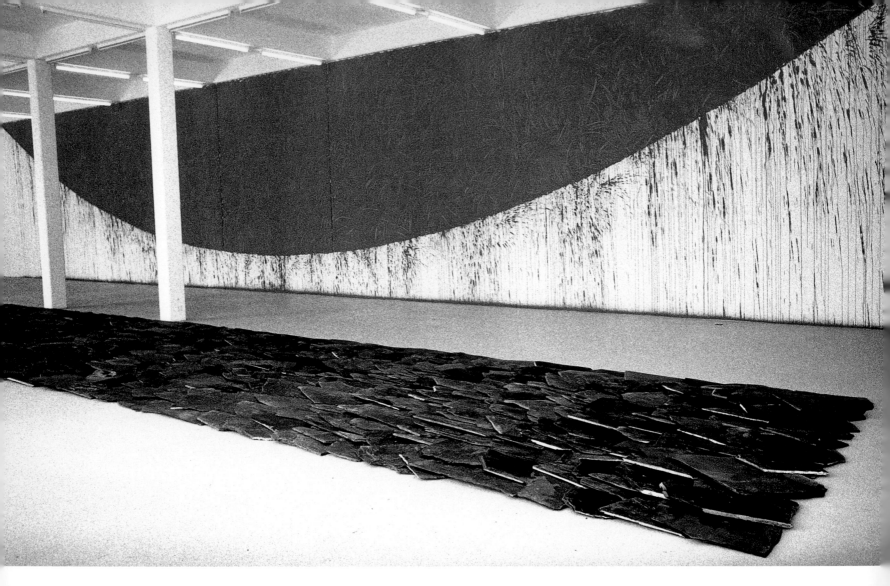

GLARUS ARC AND GLARUS LINE GALERIE TSCHUDI GLARUS SWITZERLAND 1996

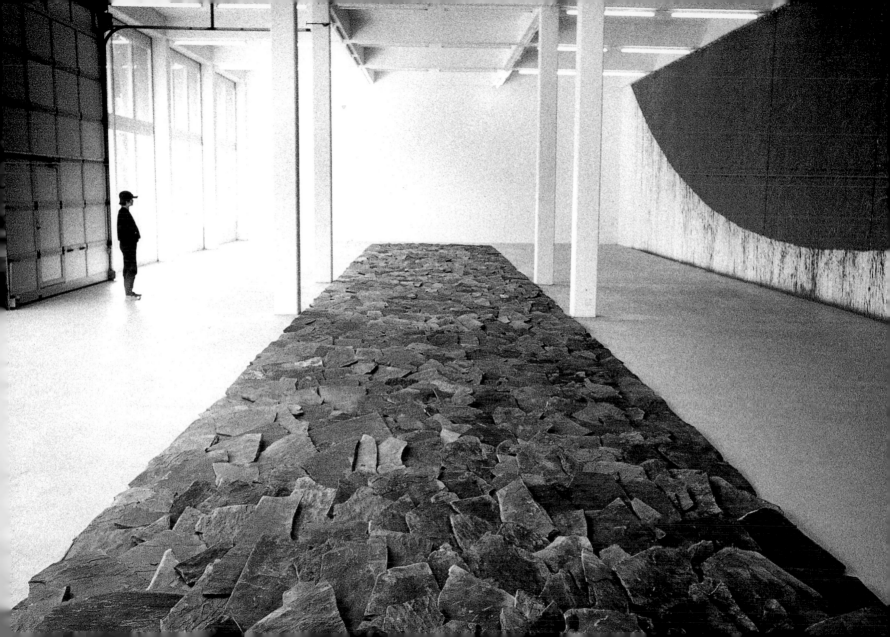

BERLIN CIRCLE HAMBURGER BANHOF MUSEUM FÜR GEGENWART BERLIN 1996

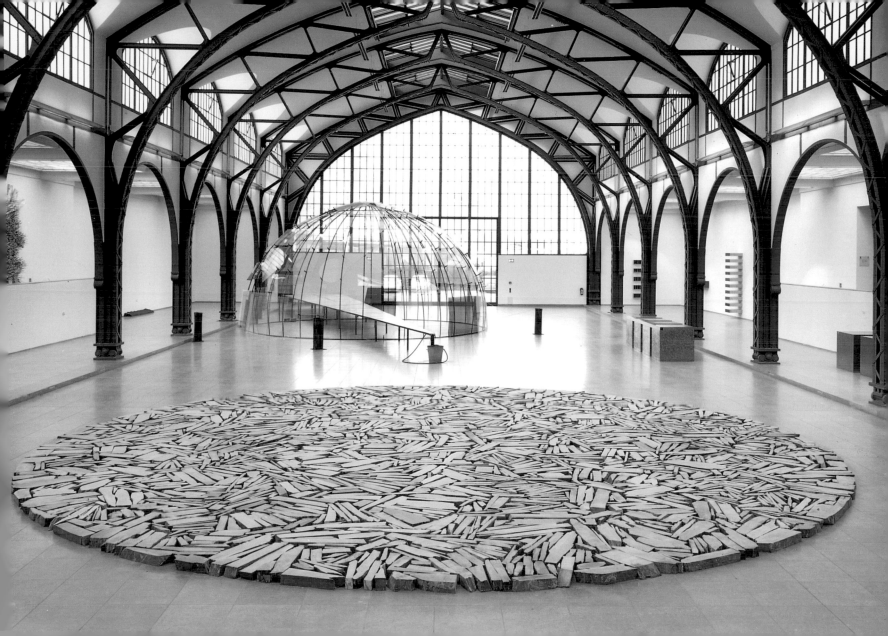

MONGOLIA 1996

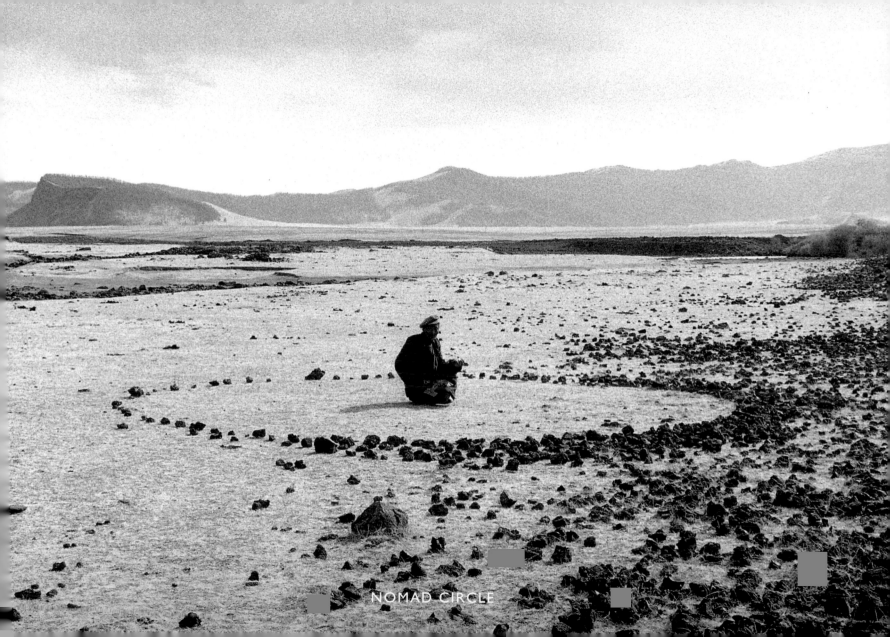

NOMAD CIRCLE

ASIA CIRCLE STONES

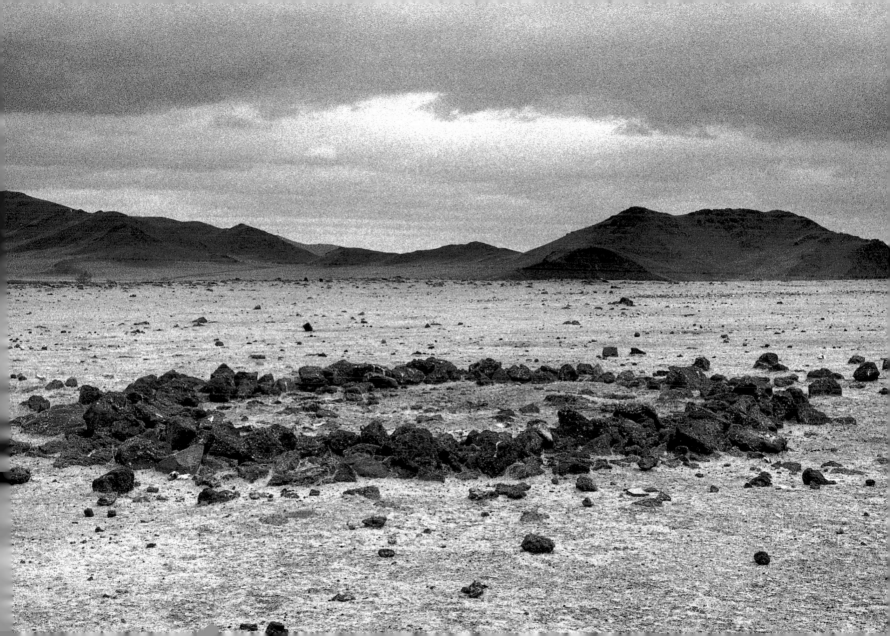

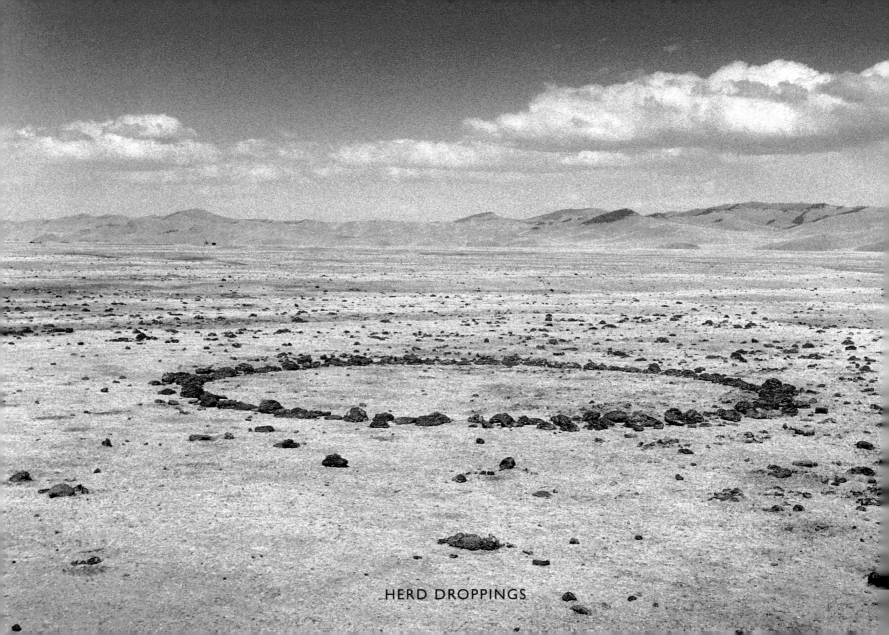

HERD DROPPINGS

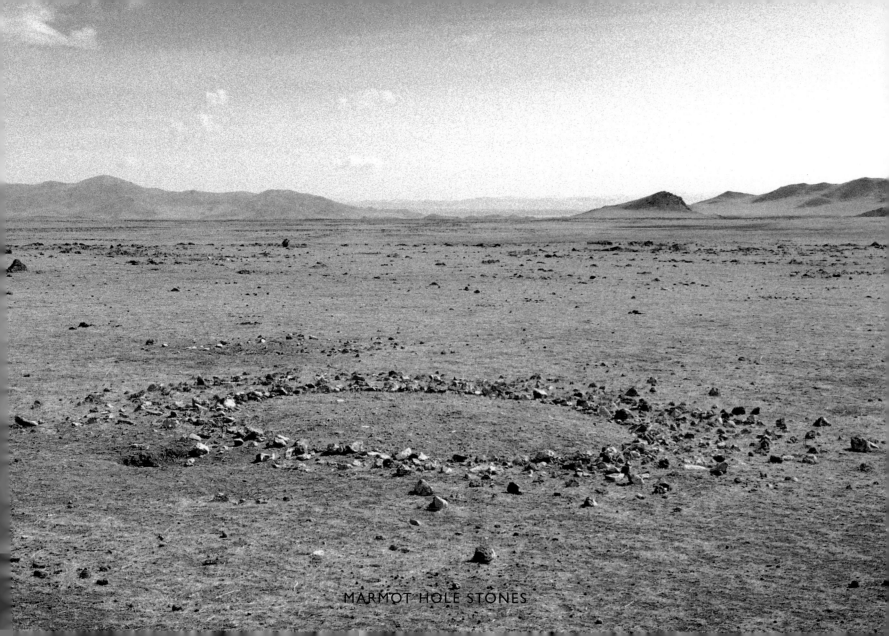

MARMOT HOLE STONES

GOBI DESERT CIRCLE

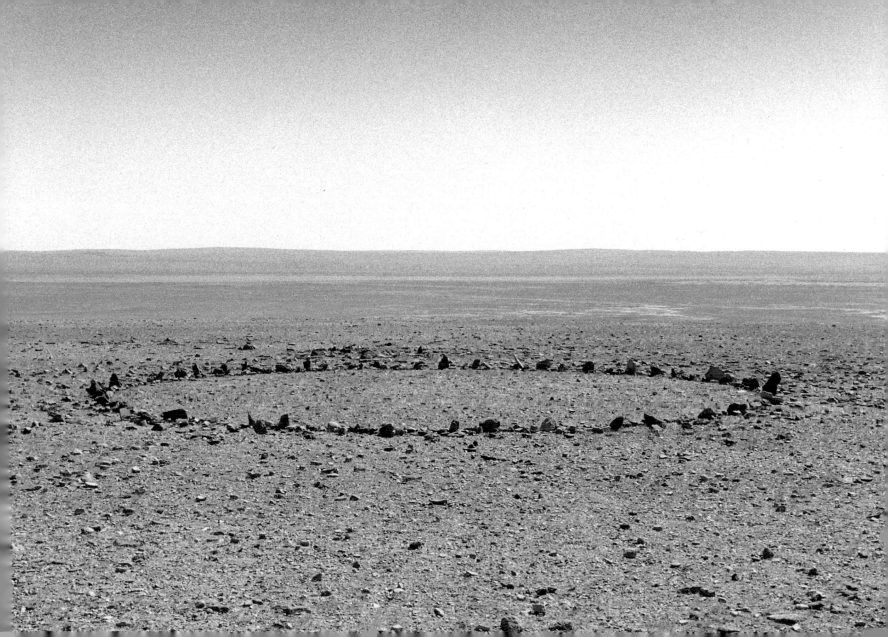

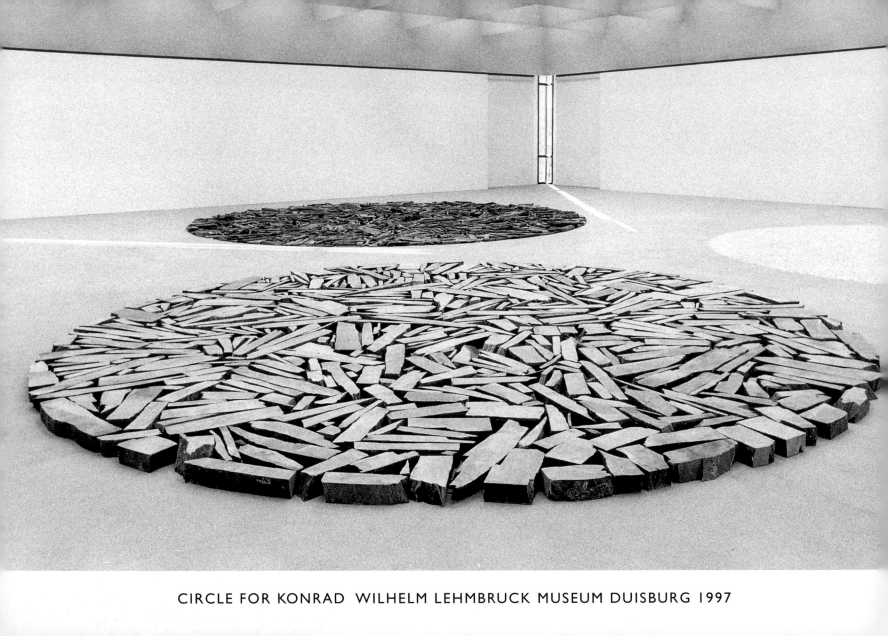

CIRCLE FOR KONRAD WILHELM LEHMBRUCK MUSEUM DUISBURG 1997

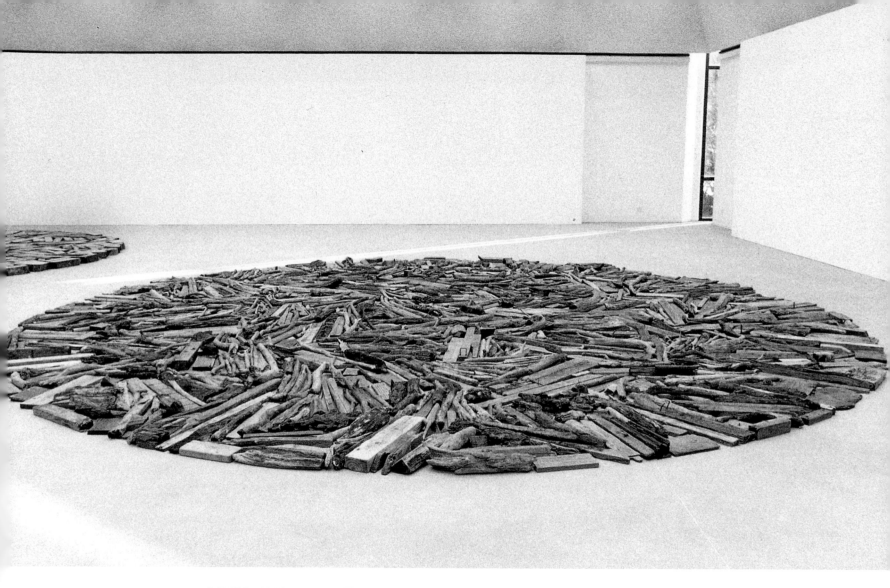

RIVER AVON DRIFTWOOD CIRCLE (1996) DUISBURG 1997

PUGET SOUND MUD CIRCLES HENRY ART GALLERY UNIVERSITY OF WASHINGTON SEATTLE 1997

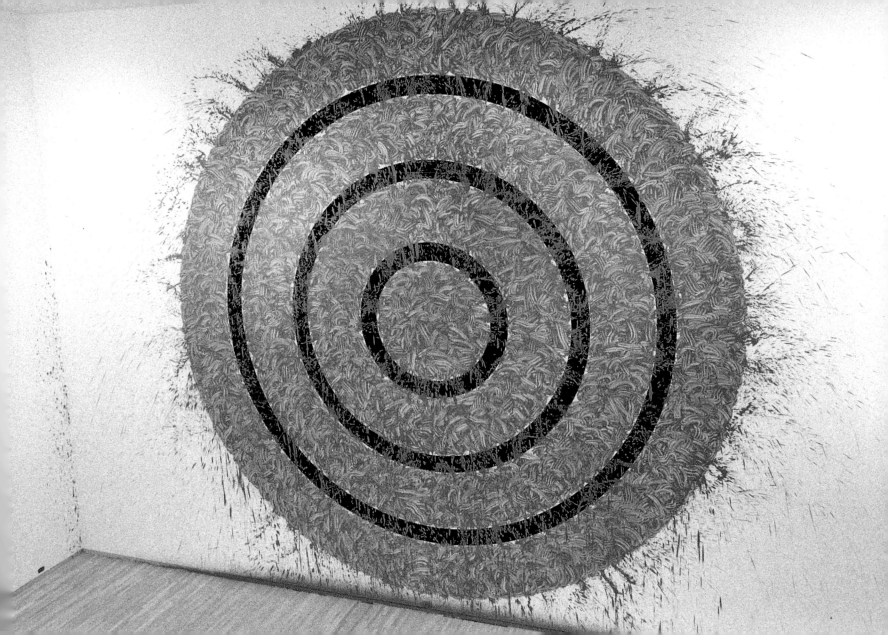

MUDDY WATER WALK

FROM BRISTOL TO THE THE SEA

FROM RIVER WATER AT NETHAM WEIR AT THE TIDE HEAD
TO OCEAN WATER AT MORTE POINT IN DEVON
A COASTAL WALK KEEPING THE MUDDY WATER OF THE BRISTOL CHANNEL IN VIEW EACH DAY

120 MILES IN 4 DAYS

ENGLAND 1996

THE SAME THING
AT A DIFFERENT TIME
AT A DIFFERENT PLACE

A STONE BROUGHT FROM SOMEWHERE ON A PAST WALK
PLACED ON THE SUMMIT OF SNOWDON FOR A TIME DURING A FIVE DAY WALK IN NORTH WALES
AND CARRIED DOWN TO BE LEFT SOMEWHERE ON A FUTURE WALK

WINTER 1997

A WALK IN A GREEN FOREST

TWO SNAKES A DOUBLE HALO AROUND THE SUN CROAKING FROGS
SUMMER AIR CONDENSING OVER WINTER SNOW RAIN HAMMERING ON
THE TENT RIVERS TURNING FROM CLEAR TO MUDDY CLOUDY NIGHT
NO-MOON BLACKNESS A MUD SLIDE ROCKS CRACKING TO THE TOUCH
GLOW-WORMS WATCHING MOONLIGHT TURNING INTO DAWN THE
FOOTPATH PASSING THROUGH A CLEFT TREE A NIGHT OF THUNDER AND
LIGHTNING A LARGE CHESTNUT TREE STRUCK DOWN A FAMILY OF
MONKEYS THE MILKY WAY SHINING BETWEEN THE CRESTS OF A RAVINE
MAGNOLIA TREES LIKE PATCHES OF SNOW CUCKOOS AND WOODPECKERS
SITTING ON A MOUNTAINTOP AMID BEECHES AND BAMBOO THE DAYTIME
RACKET OF FOREST LIFE SLEEPING BY THE SOUNDS OF A RIVER AND A
WATERFALL UNDER A TREE THE CHAOTIC BEAT OF RAINDROPS STREAMS
RISING AND FALLING WITH PASSING DOWNPOURS BREAKING CAMP
AND BREAKING A CIRCLE A WINDLESS WALK TADPOLES AND LILAC

EIGHT DAYS WALKING IN THE SHIRAKAMI MOUNTAINS

AOMORI JAPAN 1997

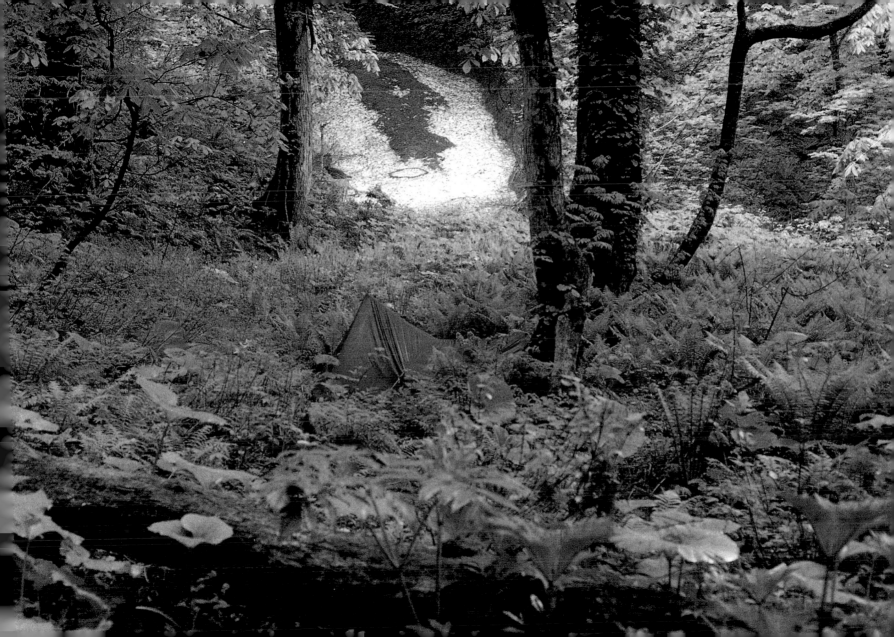

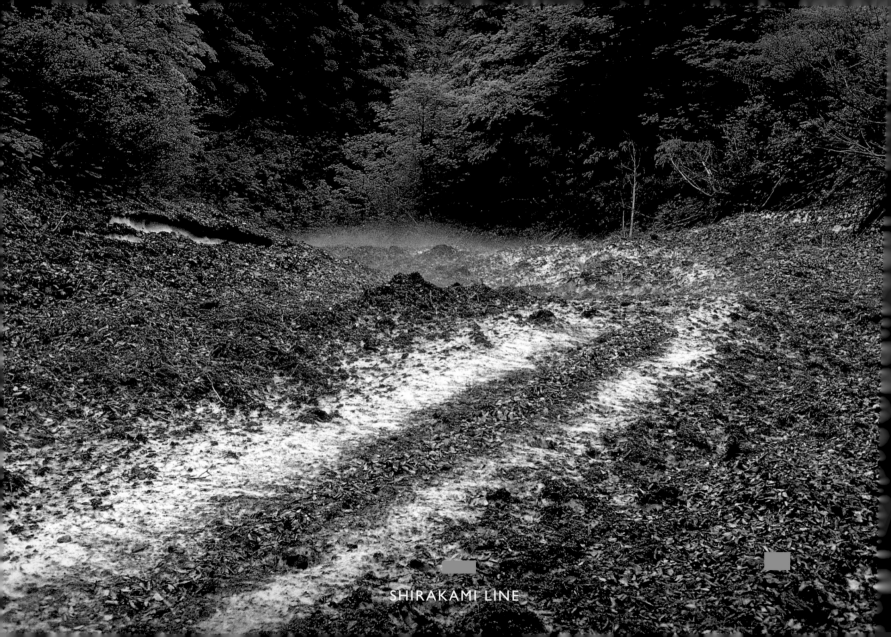

SHIRAKAMI LINE

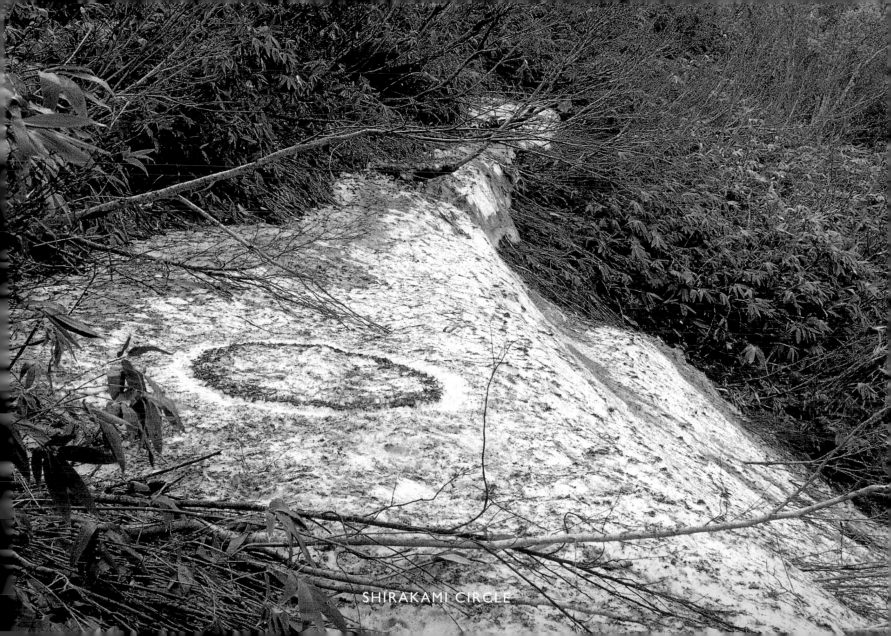

SHIRAKAMI CIRCLE

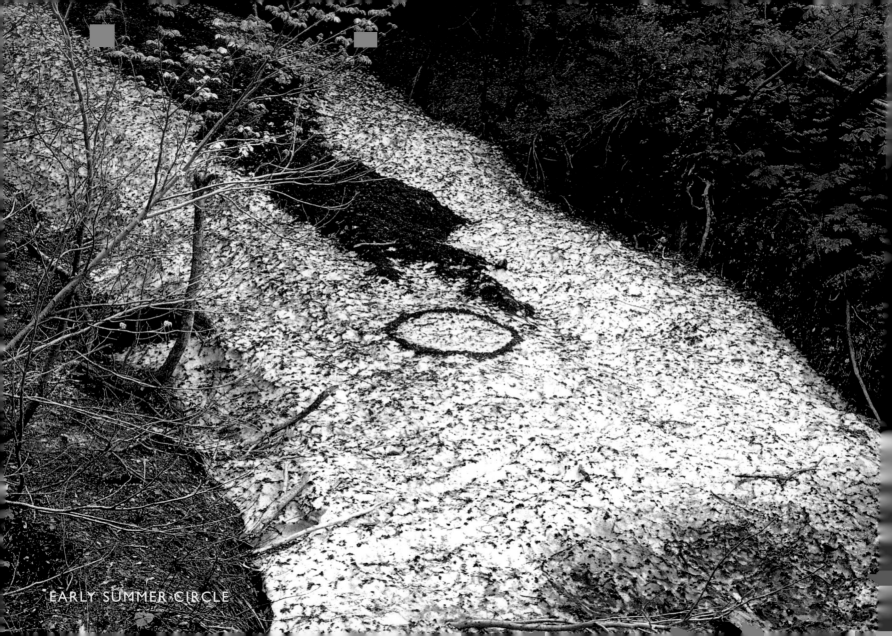

EARLY SUMMER CIRCLE

TIERRA DEL FUEGO CIRCLE ALONG A SIX DAY WINTER WALK ARGENTINA 1997

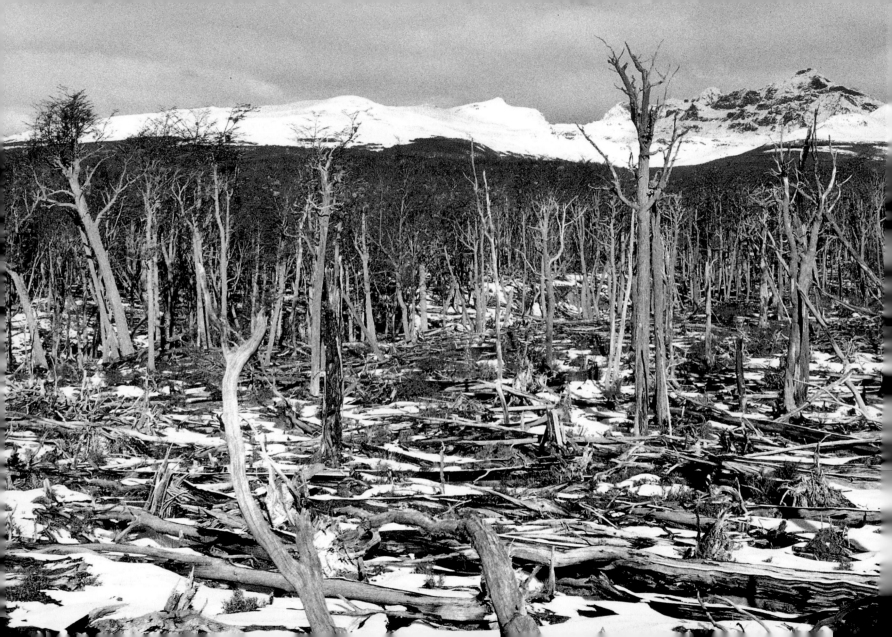

TO BUILD A FIRE

A SIX DAY WINTER WALK ON TIERRA DEL FUEGO
BUILDING A FIRE EACH DAY AT EACH CAMPSITE ALONG THE WAY

ASHES BLOWING IN THE WIND

ARGENTINA 1997

PATAGONIA 1997

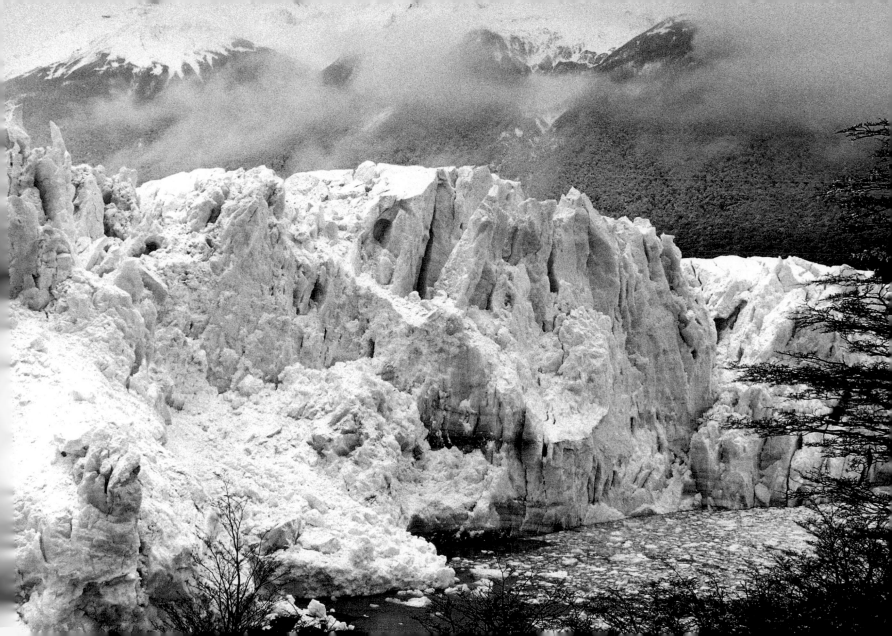

RICHARD LONG

1945 Born Bristol, England
1962-5 Studied at West of England College of Art, Bristol
1966-8 Studied at St Martin's School of Art, London
Lives and works in Bristol

SOLO EXHIBITIONS

1968	Düsseldorf	Konrad Fischer
1969	New York	John Gibson Gallery
	Düsseldorf	Konrad Fischer
	Krefeld	Museum Haus Lange
	Paris	Galerie Yvon Lambert
	Milan	Lambert Gallery
1970	New York	Dwan Gallery
	Mönchengladbach	Städtisches Museum
	Düsseldorf	Konrad Fischer
1971	Turin	Gian Enzo Sperone
	Oxford	Museum of Modern Art
	Amsterdam	Art and Project
1972	London	Whitechapel Art Gallery
	New York	The Museum of Modern Art (Projects)
	Paris	Galerie Yvon Lambert
1973	Amsterdam	Stedelijk Museum
	Antwerp	Wide White Space
	Düsseldorf	Konrad Fischer
	London	Lisson Gallery
1974	New York	John Weber Gallery
	Edinburgh	Scottish National Gallery of Modern Art
	London	Lisson Gallery
1975	Düsseldorf	Konrad Fischer
	Antwerp	Wide White Space
	Paris	Galerie Yvon Lambert
	Amsterdam	Art and Project

	Basle	Rolf Preisig Gallery
	Plymouth	Plymouth School of Art
1976	Rome	Gian Enzo Sperone Gallery
	Düsseldorf	Konrad Fischer
	Antwerp	Wide White Space
	London	Lisson Gallery
	Venice	British Pavilion, Venice Biennale
	Tokyo	Art Agency Tokyo
	Bristol	Arnolfini
	New York	Sperone Westwater Fischer Gallery
1977	London	Whitechapel Art Gallery
	Amsterdam	Art and Project
	Poznan	Gallery Akumalatory
	Basle	Rolf Preisig Gallery
	London	Lisson Gallery
	Berne	Kunsthalle
	Melbourne	National Gallery of Victoria
	Sydney	Art Gallery of New South Wales
1978	Amsterdam	Art and Project
	Paris	Galerie Yvon Lambert
	Düsseldorf	Konrad Fischer
	London	Lisson Gallery
	Leeds	Park Square Gallery
	New York	Sperone Westwater Fischer Gallery
	Hamburg	Austellungsraum Ulrich Ruckriem
1979	Zurich	Ink Gallery
	London	Anthony d'Offay Gallery
	Basle	Rolf Preisig Gallery
	Londonderry	Orchard Gallery
	Southampton	Photographic Gallery, Southampton University
	Eindhoven	Stedelijk van Abbemuseum
	London	Lisson Gallery
	Tokyo	Art Agency Tokyo
	Oxford	Museum of Modern Art
1980	Athens	Karen and Jean Bernier Gallery
	Amsterdam	Art and Project

	Cambridge	Fogg Art Museum, Harvard University
	New York	Sperone Westwater Fischer Gallery
	London	Anthony d'Offay Gallery
	Düsseldorf	Konrad Fischer
1981	New York	Sperone Westwater Fischer Gallery
	Edinburgh	Graeme Murray Gallery
	Düsseldorf	Konrad Fischer
	London	Anthony d'Offay Gallery
	Toronto	David Bellman Gallery
	Bordeaux	CAPC, Musée d'Art Contemporain de Bordeaux
1982	Amsterdam	Art and Project
	Paris	Galerie Yvon Lambert
	Los Angeles	Flow Ace Gallery
	New York	Sperone Westwater Fischer Gallery
	Ottawa	National Gallery of Canada
1983	Toronto	David Bellman Galllery
	Bristol	Arnolfini
	London	Anthony d'Offay Gallery
	Turin	Galleria Tucci Russo
	Tokyo	Art Agency Tokyo
	Tokyo	Century Cultural Centre
	Düsseldorf	Konrad Fischer
1984	London	Coracle Press
	Naples	Lucio Amelio Gallery
	Paris	Gallery Crousel-Hussenot
	Athens	Jean Bernier Gallery
	New York	Sperone Westwater Gallery
	Dallas	Dallas Museum of Art
	Kilkenny	The Butler Gallery, Kilkenny Castle
	Londonderry	Orchard Gallery
	London	Anthony d'Offay Gallery
	Düsseldorf	Konrad Fischer
1985	Basle	Gallery Buchmann
	London	Anthony d'Offay Gallery
	Kendal	Abbot Hall

	Malmö	Malmö Konsthall
	Milan	Padiglione d'Arte Contemporanea
1986	Madrid	Palacio de Cristal
	Paris	Galerie Crousel-Hussenot
	New York	Solomon R. Guggenheim Museum
	New York	Sperone Westwater Gallery
	London	Anthony d'Offay Gallery
	Pori, Finland	Porin Taidemuseo
	Turin	Galleria Tucci Russo
1987	Geneva	Musée Rath
	Liverpool	Coracle Atlantic Foundation, Renshaw Hall
	Chicago	Donald Young Gallery
	Nailsworth	Cairn Gallery
	Grenoble	Centre National d'Art Contemporain de Grenoble Magasin
	Athens	Jean Bernier Gallery
1988	Düsseldorf	Konrad Fischer
	Aachen	Neue Galerie–Sammlung Ludwig
	London	Anthony d'Offay Gallery
1989	St Gallen	Kunstverein St Gallen
	Athens	Jean Bernier Gallery
	Turin	Galleria Tucci Russo
	Bristol	Coopers Gallery
	New York	Sperone Westwater Gallery
	Bristol	Bristol Old Vic Theatre
	Chagny	Pietro Sparta Gallery
	La Jolla	La Jolla Museum of Contemporary Art
	Halifax	Henry Moore Sculpture Trust Studio, Dean Clough
1990	Bristol	Arnolfini
	London	Anthony d'Offay Gallery
	Los Angeles	Angles Gallery
	Glarus	Galerie Tschudi
	Düsseldorf	Konrad Fischer
	London	Tate Gallery

	Stockholm	Magazine 3 Konsthall
	Rochechouart	Château de Rochechouart
1991	Liverpool	Tate Gallery
	Frankfurt	St Delsches Kunstinstitut und Städtische Galerie
	London	Hayward Gallery
	Turin	Galleria Tucci Russo
	New York	Sperone Westwater Gallery
	Edinburgh	Scottish National Gallery of Modern Art
	Glarus	Galerie Tschudi
1992	Athens	Jean Bernier Gallery
	Los Angeles	Angles Gallery
	Warwick	Mead Gallery, University of Warwick
	Barcelona	Fundacio Espai Poblenou
	Düsseldorf	Konrad Fischer
1993	New York	65 Thompson Street
	Paris	ARC, Musée d'Art Moderne de la Ville de Paris
	Seoul	Inkong Gallery
	London	Anthony d'Offay Gallery
	Bremerhaven	Kunstverein Bremerhaven
	Santa Fe	Center for Contemporary Arts
	Bremen	Newen Museum Weserburg
	Glarus	Galerie Tschudi
	New York	Sperone Westwater Gallery
1994	Düsseldorf	Kunstsammlung Nordrhein Westfalen
	New York	New York Public Library
	Düsseldorf	Konrad Fischer
	New York	Sperone Westwater Gallery
	Philadelphia	Philadelphia Museum of Art
	Rome	Palazzo delle Esposizioni
	Santa Fe	Center for Contemporary Arts
	Orkney	Pier Arts Centre
	São Paulo	São Paulo Bienal

	Sydney	Museum of Contemporary Art
	Sydney	Sherman Galleries
	Torre Pellice	Galleria Tucci Russo
	Huesca	Sala de Exposiciones de la Diputacion de Huesca
1995	Bünde	Bündner Kunstverein and Bündner Kunstmuseum
	New York	Peter Blum, Blumarts Inc
	Santa Fe	Laura Carpenter Fine Art
	London	Anthony d'Offay Gallery
	Glarus	Galerie Tschudi
	Düsseldorf	Konrad Fischer
	Reykjavik	Syningarsalur
	San Francisco	Daniel Weinberg Gallery
1996	Tokyo	Setagaya Art Museum
	Kyoto	National Museum of Modern Art
	Exeter	Spacex Gallery
	Bolzano	AR/GE KUNST Galerie Museum
	Glarus	Galerie Tschudi
	Houston	Contemporary Arts Museum
	Fort Worth	Modern Art Museum of Fort Worth
1997	Duisburg	Wilhelm Lehmbruck Museum
	St Andrews	Crawford Arts Centre
	Naoshima	Benesse Museum of Contemporary Art
	New York	Sperone Westwater Gallery
	Palermo	Spazio Zero, Cantieri Culturali 'La Zisa'

SELECTED GROUP EXHIBITIONS

1966	Frankfurt	Galerie Loehr
1969	Amsterdam	*Op Losse Schroeven*, Stedelijk Museum
	Berne	*When Attitudes Become Form*, Kunsthalle
1970	New York	*Information*, The Museum of Modern Art
1971	New York	*Guggenheim International*, Solomon R. Guggenheim Museum
1972	Kassel	*Documenta V*
	London	*The New Art*, Hayward Gallery
1976	Milan	*Arte Inglese Oggi*, Palazzo Reale
	Dublin	*ROSC*, Hugh Lane Municipal Gallery of Modern Art
1979	Paris	*Un Certain Art Anglais*, Musée d'Art Moderne de la Ville de Paris
1980	London	*Pier + Ocean*, Hayward Gallery
	Venice	Venice Biennale
1982	Kassel	*Documenta VII*
1983	Helsinki	*ARS 83*, Museum of the Atheneum
1984	New York	*Primitivism in 20th Century Art: An Affinity of the Tribal and the Modern*, The Museum of Modern Art
	Dublin	*ROSC'84*, Guinness Hop Store
1987	Chicago	*A Quiet Revolution*, Museum of Contemporary Art
1988	Liverpool	*Starlit Waters: British Sculpture, An International Art 1968-1988*, Tate Gallery
1989	Istanbul	Istanbul Biennale
1990	Lincoln	*The Journey*, Lincoln Cathedral, Lincolnshire Collection
1993	London	*Gravity and Grace*, Hayward Gallery
1994	São Paulo	São Paulo Bienal
1996	New York	*Material Imagination*,
	New York	The Guggenheim, Soho *Abstraction in Twentieth Century Art*, Solomon R. Guggenheim Museum
	Bristol	*Swinging the Lead*, The Old Leadworks
	Tokyo	*A Diverse Boat*, Tokyo Forum
1997	Corte	*Géographique*, FRAC, Corsica

AWARDS AND PRIZES

1988	Aachen	Kunstpreis Aachen. Neue Galerie–Sammlung Ludwig
1989	London	Turner Prize, Tate Gallery – Patrons of New Art
1990	Paris	Chevalier de l'Ordre des Arts et des Lettres, French Ministry of Culture
1995	Germany	Wilhelm Lehmbruck Prize

FILMS ON AND BY THE ARTIST

WALKING A STRAIGHT LINE TEN MILES LONG
OUT AND BACK DARTMOOR ENGLAND 1969
Made for 'Land Art', Fernsehgalerie Gerry Schum, and telecast
in April 1969 by Sender Freies Berlin.
6 minutes 33 seconds, colour, sound.

RICHARD LONG.
'Omnibus', BBC Television, Autumn 1982.

STONES AND FLIES: RICHARD LONG IN THE SAHARA
Directed and Produced by Philip Haas. A Methodact
Production for the Arts Council of Great Britain in association
with Channel 4 Television, HPS Film, Berlin, and Centre
Pompidou, LA SEPT, CNAP and WDR, 1988
Colour, 16mm and VHS, 38 minutes

PUBLICATIONS

RICHARD LONG SKULPTUREN
Städtisches Museum, Mönchengladbach 1970

FROM ALONG A RIVERBANK
Art and Project, Amsterdam 1971

TWO SHEEPDOGS CROSS IN AND OUT OF THE
PASSING SHADOWS, THE CLOUDS DRIFT OVER THE
HILL WITH A STORM
Lisson Publications, London 1971

SOUTH AMERICA
Konrad Fischer, Düsseldorf 1973

FROM AROUND A LAKE
Art and Project, Amsterdam 1973

JOHN BARLEYCORN
Stedelijk Museum, Amsterdam 1973

INCA ROCK CAMPFIRE ASH
Scottish National Gallery of Modern Art,
Edinburgh 1974

THE NORTH WOODS
Whitechapel Art Gallery, London 1977

A HUNDRED STONES
Kunsthalle, Berne 1977

A STRAIGHT HUNDRED MILE WALK IN AUSTRALIA
John Kaldor, Project 6, Sydney 1977

RIVERS AND STONES
Newlyn Art Gallery, Newlyn 1968

RIVER AVON BOOK
Anthony d'Offay Gallery, London 1979

RICHARD LONG
Van Abbemuseum, Eindhoven 1979

AGGIE WESTON'S No 16
Coracle Press, London 1979

A WALK PAST STANDING STONES
Anthony d'Offay Gallery, London 1979

FIVE, SIX, PICK UP STICKS
Anthony d'Offay Gallery, London 1980

TWELVE WORKS 1979-1981
Anthony d'Offay Gallery, London 1981

RICHARD LONG BORDEAUX 1981
Centre d'Arts Plastiques Contemporains, Bordeaux 1982

MEXICO 1979
Van Abbemuseum, Eindhoven 1982

SELECTED WORKS/ OEUVRES CHOISIES 1979-1982
National Gallery of Canada, Ottawa 1982

TOUCHSTONES
Arnolfini, Bristol 1983

COUNTLESS STONES
Van Abbemuseum, Eindhoven and Openbaar
Kunstbeizeit 1983

FANTO PIETRE LEGNI
Galleria Tucci Russo, Turin 1983

PLANES OF VISION
Ottenhausen Verlag, Aachen 1983

SIXTEEN WORKS
Anthony d'Offay Gallery, London 1984

MUD HAND PRINTS
Coracle Press, London 1984

RIVER AVON MUD WORKS
Orchard Gallery, Londonderry 1984

POSTCARDS 1968-1982
Musée d'Art Contemporain de Bordeaux, Bordeaux 1984

RICHARD LONG
Century Cultural Foundation, Tokyo 1984

RICHARD LONG,
Fonds Regional d'Art Contemporain Aquitaine,
Bordeaux 1985

MUDDY WATER FALLS
MW Press, Noordwijk 1985

IL LUOGO BUONO
Padiglione d'Arte Contemporanea, Milan 1985

RICHARD LONG IN CONVERSATION:
PARTS ONE AND TWO
MW Press, Noordwijk 1986

PIEDRAS
Ministerio de Cultura, Madrid 1986

LINES OF TIME
Stitchting Edy de Wilde-Lezing, Amsterdam 1986

RICHARD LONG
Thames and Hudson, London and The Solomon
R. Guggenheim Foundation, New York 1986,
text by Rudi Fuchs

STONE WATER MILES
Musée Rath, Geneva 1987

OUT OF THE WIND
Richard Long, Donald Young Chicago 1987

DUST DOBROS DESERT FLOWERS
The Lapis Press, Los Angeles 1987

OLD WORLD NEW WORLD
Anthony d'Offay Gallery, London & Walther König,
Cologne 1988, text by Anne Seymour

ANGEL FLYING TOO CLOSE TO THE GROUND
Kunstverein, St Gallen 1989

SURF ROAR
La Jolla Museum of Contemporary Art, La Jolla 1989,
text by Hugh M. Davis

KICKING STONES
Anthony d'Offay Gallery, London 1990

TATE GALLERY BROADSHEET
Tate Gallery, Turner Prize Publications, London 1990,
text by Nicholas Serota and Richard Long

SUR LA ROUTE
Musée Departmental de Rochechouart, Rochechouart
1990, text by Guy Tosatto

RICHARD LONG
Magasin 3 Konsthall, Stockholm 1990, text by Roger Bevan

NILE
The Lapis Press, Los Angeles, 1990

WALKING IN CIRCLES
Thames and Hudson, London 1991,
text by Anne Seymour and Richard Cork

RIVER TO RIVER
Musée d'Art Moderne de la Ville de Paris, Paris 1993

NO WHERE
Pier Arts Centre, Orkney 1994

RICHARD LONG
Kunstsammlung Nordfhein-Westfalen, Düsseldorf 1994

RICHARD LONG SÃO PAULO BIENAL
British Council, London 1994, interview between Geórgia
Lobacheff and Richard Long

RICHARD LONG
Electa, Milan 1994

RICHARD LONG COLORADO AND NEW MEXICO 1993
The Center for Contemporary Arts, Santa Fe
1994, interview by Neery Melkonian

RICHARD LONG SOMERSET WILLOW LINE
Blumarts Inc., New York 1995,
text by Jean-Christophe Ammann

RICHARD LONG CIRCLES CYCLES MUD STONES
Contemporary Arts Museum, Houston 1996

FROM TIME TO TIME
Cantz, Stuttgart 1997

A WALK ACROSS ENGLAND
Children's Library Press, Los Angeles,
and Thames & Hudson, London 1997

Phaidon Press Limited
Regent's Wharf
All Saints Street
London N1 9PA

Phaidon Press Inc.
180 Varick Street
New York, NY 10014

www.phaidon.com

First published 1998
Reprinted 2003

English edition, with additions, © 1998 Phaidon Press Limited
Original Italian edition first published by West Zone
Publishing in 1997, compiled on the occasion of the Richard
Long exhibition at Spazio Zero, Cantieri Culturali 'La Zisa',
Palermo, 1997, curated by Mario Codognato and Paolo
Falcone

Photographs © Richard Long, Enzo Ricci (Rome Circle,
Romulus Circle, Remus Circle, Pietra di Luserna Line, Muddy
Water Circles, Roma), Shobha Laboratorio (Palermo
Exhibition, 1997), Jens Ziehe (Berlin Circle)
Interview © Richard Long and Mario Codognato

A CIP catalogue record for this book is available from the
British Library

ISBN 0 7148 3779 2

Printed in China

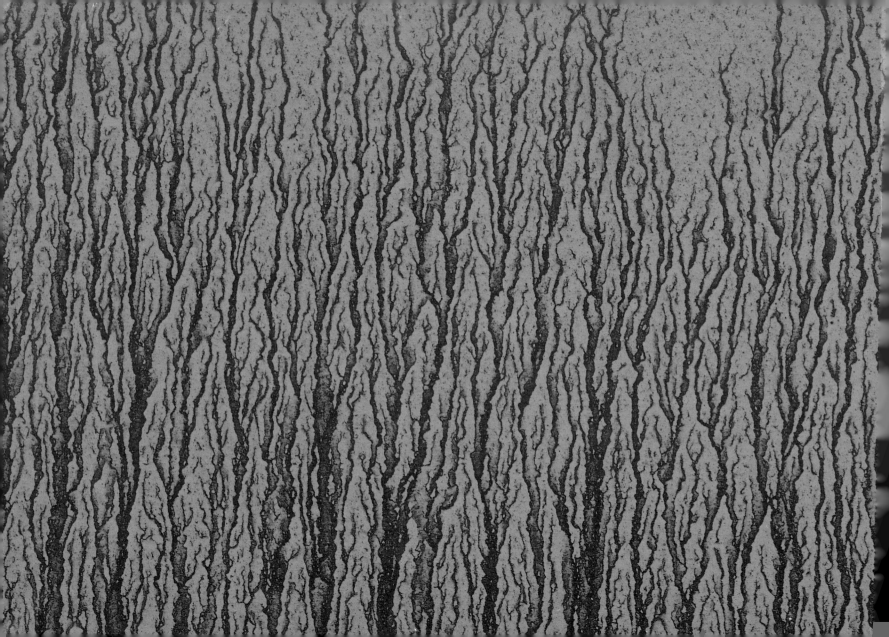